IMAGES
of America

KANSAS CITY'S
PARKS AND BOULEVARDS

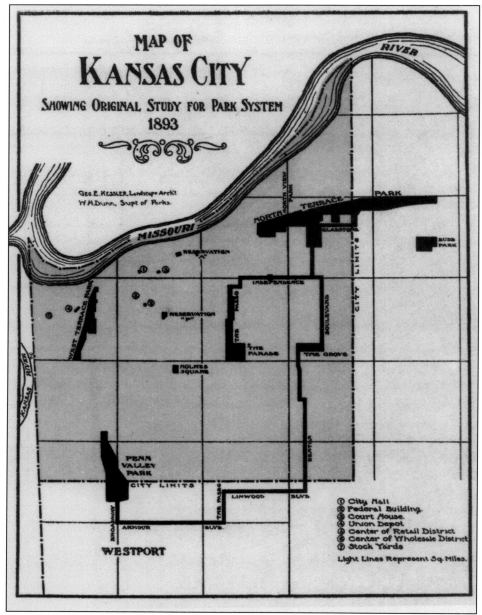

In 1893, the newly formed Kansas City, Missouri, Board of Park and Boulevard Commissioners prepared a report. The board proposed 9.85 miles of boulevards and 318.4 acres of parks and pleasure grounds. Widely separated sections of the city, in distance and in rugged topography, would be united into a homogeneous whole. The forward-looking vision provided design principles that guided the city's development into the 21st century. (Courtesy of BPRC.)

ON THE COVER: In 1911, work begins on a large free-form wading pool. It was for women and children and was constructed in a creek bed in the central wooded area of The Grove park. Curved edges with overhanging shrubbery and trees gave the pool a natural setting. This photograph looks south around 1912. The pool's fountains at both ends are clearly visible. (Courtesy of BPRC.)

IMAGES
of America

KANSAS CITY'S
PARKS AND BOULEVARDS

Patrick Alley and Dona Boley

ARCADIA
PUBLISHING

Copyright © 2014 by Patrick Alley and Dona Boley
ISBN 978-1-4671-1259-8

Published by Arcadia Publishing
Charleston, South Carolina

Printed in the United States of America

Library of Congress Control Number: 2014934089

For all general information, please contact Arcadia Publishing:
Telephone 843-853-2070
Fax 843-853-0044
E-mail sales@arcadiapublishing.com
For customer service and orders:
Toll-Free 1-888-313-2665

Visit us on the Internet at www.arcadiapublishing.com

CONTENTS

ACKNOWLEDGMENTS

While preparing this book, we had extensive help and cooperation from many people and institutions. We thank everyone who gave us suggestions and shared stories and ideas. The Historic Kansas City Foundation was very generous to supply several images.

We especially want to thank Ann McFerrin, archivist for the Kansas City, Missouri, Parks and Recreation Department. Without Ann's total commitment and full cooperation on our project, this book would not have been possible. Thank you, Ann! We also feel honored to have the support of the Kansas City, Missouri, Board of Parks and Recreation Commissioners and the Parks and Recreation Department.

The Missouri Valley Special Collections of the Kansas City Public Library was also immensely helpful and generous with its photographs of the parks and boulevards. We would especially like to single out Jeremy Drouin for his help.

The Historic Kansas City Foundation, Kansas City Museum/Union Station, Missouri History Museum, and the National World War I Museum at Liberty Memorial gave us generous use of their resources.

We wish to thank the Kessler Society, which supplied us with the necessary funding for some of the images in the book.

Lastly, but most importantly, we thank Bill Boley and Jane Alley, our spouses, for their support and understanding while we were writing this book, fretting over content, and running up against deadlines. You were always there with encouraging words when we most needed them.

Photographic sources are abbreviated as follows:
BPRC: Board of Parks and Recreation Commissioners of Kansas City, Missouri
HKCF: Historic Kansas City Foundation
KCM-US: Kansas City Museum/Union Station Kansas City
Library of Congress: Library of Congress
MHM: Missouri History Museum, St. Louis, Missouri
MVSC-KCPL: Missouri Valley Special Collections, Kansas City, Missouri, Public Library
NWWIM: National World War I Museum at Liberty Memorial, Kansas City, Missouri
WAP: Wilborn & Associates Photographers, Kansas City, Missouri

INTRODUCTION

Almost 25,000 people lived in Kansas City, Missouri, when the first railroad bridge crossed the Missouri River in 1869. Most streets were unimproved, city finances were in shambles due to extensive fraud, large public improvement bond issues had not passed, and there was no water system. But there was a vision of what Kansas City could become. A vision shaped over the next 40 years making this rustic town a vibrant, healthy, well-planned community. An extensive parks and boulevard system was an important part of that vision. The combined efforts of a charismatic newspaper editor, a prominent businessman, a shrewd attorney, a skillful landscape architect, and a powerful political boss were all needed before the vision became reality. By 1880, Kansas City's population had doubled to 55,000, and it would double again to 119,668 by 1890. New arrivals and established residents recognized the need for planning and beautification.

The effort began in 1872 when J.W. Cook offered land at $2,000 an acre to the city for a 40-acre park. The offer was turned down. Cook was back in the summer of 1877. The council again failed to act on his proposal, but they did grade the old graveyard at the southeast corner of the original town for a public park. This became the city's first park in 1880. The old graveyard park led the press to complain that a larger plot of ground was necessary, and the newspapers began an editorial campaign for city parks.

Park advocates wanted a park board with the legal powers necessary to condemn and control the required land, to be free from political interference yet subject to political checks, and with its own independent source of revenue. To accomplish this, the advocates needed either the state legislature to grant powers to a park board, or to convince the people of Kansas City to incorporate these powers into the city charter. It would take eight years of legislation and twelve years of litigation before the legal framework was in place that allowed the successful implementation of the parks and boulevard system.

The charter of 1875 allowed the city to condemn land for parks but required the city to pay in full before it could take possession and required the city to get state permission to issue bonds for any improvements. In 1889, the voters did approve a new charter creating a park board, but one powerless to issue bonds. Meanwhile, the state passed legislation that created a parks board with powers to create a park district within Jackson County. This law became effective in November 1889. But the newly appointed park board ceased in January 1891, when the Missouri State Supreme Court declared the law unconstitutional.

This motivated a newly formed Municipal Improvement Association to launch a campaign to amend the park provision of the 1889 charter. The citizens approved, and in 1892, Mayor Ben Holmes appointed a new board with the power to issue city bonds. August Robert Meyer, president of the Municipal Improvement Association, became the first president of the new parks board. Meyer, a multimillionaire businessman, arrived in Kansas City in 1882 and became an early advocate for beautification. With extensive travel in the United States and Europe, he gathered ideas for park development. He knew that "a good deal of our work will have to be education." The

parks board's great early achievement was the 1893 Report of the Board of Park and Boulevard Commissioners. The report was a collaborative effort of Meyer and landscape architect George E. Kessler. It was a detailed and comprehensive look at Kansas City's topography and traffic patterns, population density and growth, its industrial and residential sections, and its prospects for future development. It was, in a word, urban planning. It contained three sections: a letter of transmittal to the mayor, a detailed report from the board, and a technical report. Meyer wrote the main body of the report and Kessler wrote the technical section. The 1893 Report has provided the urban design framework for Kansas City.

Although the report looked well on paper and was highly commended by the press, the power to go ahead with practical work was still lacking. Kansas City could not issue any more bonds. The city's debt-making power under the state constitution was exhausted. The only way to acquire parks and boulevards was through special assessment or taxation against benefited property. An 1893 state law empowered the board to form park districts and issue "certificate" bonds on the park system. It was practically an amendment of the charter. No one knew if it would stand up in court. When the act passed, the park board brought a friendly suit to the Missouri State Supreme Court as a test of the board's power to condemn land for park purposes. The court found the act unconstitutional and voided the law.

What appeared to be a knockout punch for park advocates actually cleared the way to provide the legal foundation for today's park system. Delbert J. Haff, a Kansas City attorney, was hired to draft new amendments to the charter. The amendments granted the park board power to sell tax certificates to pay for confiscated property, provided for a condemnation jury to set values, set the board's membership at five, provided for the board's control over all parks and boulevards, continued the three park districts, and required a minimum of one park in each district. These amendments, known all over the country as "the Kansas City park law," were on the ballot of a special election in 1895.

Leaving nothing to chance, supporters formed a "citizen's association for the charter amendments" to develop campaign literature and hold public information meetings. Summaries and editorials appeared in the daily press. William Rockhill Nelson arrived in Kansas City and started the *Star* in 1880. Nelson was an early and strong advocate for parks and boulevards. His paper became the public face for establishment of a parks and boulevard system in Kansas City. The *Star's* most effective technique was a combination of repetition, adulation, and humor. James Pendergast, alderman and political boss, was solicited to be an advocate for his ward. Pendergast was a proponent of public improvements. More boulevards, parks, and public buildings meant more jobs for his followers and more prestige for himself. Other contractors and ward bosses such as Mike Ross, who set out many of the elm trees lining the streets, and Hugh J. McGowan, an agent for the Barber Asphalt Company, were also supporters. Leaders of the opposition Democratic faction, such as Joe Shannon, were also included. The park amendments passed nearly six-to-one in every precinct of every ward. The citizens were in a progressive mood and also supported other major issues on the ballot such as the waterworks bonds.

Condemnation for public parks now began, and the anti-parks people had something to oppose! The anti-parks' main tactic was to delay construction so that the only tangible result that citizens would see was the tax assessments. For almost four years, from 1896 to 1900, the opponents organized a series of petitions, court fights, and public meetings, sent delegations to the council and the parks board, developed alternatives for the 1893 plan, and attempted to remove President Meyer from the parks board. The opponents represented a mix of income levels and professions. They believed a park system provided no economic advantage and were concerned about the expense. According to William M. Reddig in *Tom's Town: Kansas City and the Pendergast Legend*, Nelson's paper derided the opponents: "Those of the people who didn't want new paving, sewers and parks were organized by Nelson into Hammer and Padlock clubs (hammer for every improvement idea, a padlock on every money pocket). They were flailed, scourged and browbeaten by Nelson's reporters, cartoonists and editorial writers as croakers, knockers, mossbacks, and men without any redeeming qualities."

For several years, multiple lawsuits continued unsuccessfully to challenge the 1895 amendments. In 1898, the Missouri State Supreme Court upheld the city's right of eminent domain. In 1899, the court issued the final decision on North Terrace Park. This case concerned due process rights over condemnation values. In early 1900, a federal court case upheld the charter and denied that property rights were being violated in the takings. In June 1900, the Missouri State Supreme Court rejected another challenge to the condemnation and benefit process. This decision virtually doomed the anti-park forces, and effective opposition to the park and boulevard plan was over by 1900.

By resolution, the park board selected the lands and the connecting boulevards for each of three parks districts. The council passed ordinances, and circuit court proceedings condemned the lands. Juries assigned values and assessed the benefits in specific amounts against the land in the park district. To make the assessments as easily borne as possible by the assessed landowners, installments on the amount owed could be paid annually. Usually, the period was 20 years. Because condemned lands could not be taken until payment was made, the transaction was financed by the issue and sale of park fund certificates. These certificates were collateralized by the unpaid assessments due. Court decisions in test cases ruled that the park fund certificates were not obligations of the municipality and did not conflict with the city's debt-making power. Within each park district, an assessment for maintenance and improvement was made against the lands within the district. However, the original cost of a boulevard, except the tree plantings, was charged directly against the property fronting on that boulevard. Almost the entire cost was paid, exclusive of improvements, by assessment against the land. By 1912, twenty years after the formation of the park board, the entire system cost $11,106,223.27. Kansas City was unique among American cities in that this large sum had been paid without the issuance of any bonds, with one exception, a $500,000 issue authorized in 1903.

The original 1893 plan was not only implemented but also augmented under the guidance of one master, George E. Kessler. At completion in the 1920s, the Kansas City parks and boulevard system was the premier park system in the United States. The original 1893 plan, implemented by George Kessler, brought the idea of urban beauty to a reality not demonstrated as completely in any other American city. Kessler had converted blighted shantytowns and unsightly bluffs and ravines into urban parks connected by a picturesque system of boulevards. Boulevards increased the property values of surrounding neighborhoods by effectively removing unsightly commercial buildings and low-quality housing. Kansas City became famous for its beautiful vistas and parkways and served as a model for other communities as the City Beautiful movement spread across the nation, giving shapeless and ugly cities beauty and unity. Kansas City is deeply indebted to the men who had the foresight, tenacity, and creativity to make this legacy possible—August R. Meyer, George E. Kessler, Delbert J. Haff, and William Rockwell Nelson.

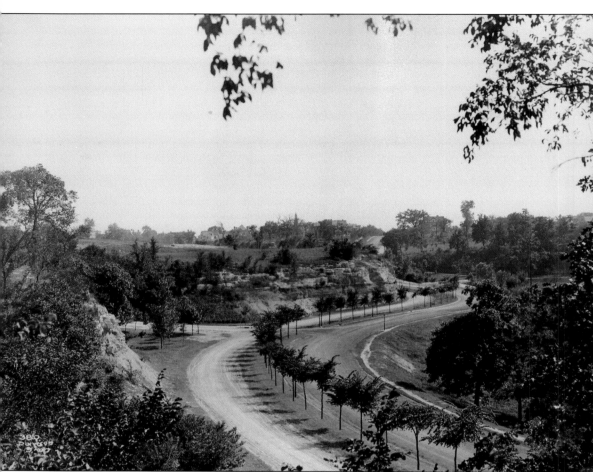

Penn Valley Drive is the major road through Penn Valley Park. This photograph from 1907 looks south from about Twenty-eighth Street. The double lanes were both two-way streets. The western road was for pleasure driving, and the eastern side was for heavy wagons and commercial vehicles. South of Thirty-first Street, Broadway Avenue continues over the horizon. In 1902, the park board incorporated Broadway Avenue into the boulevard system to join Armour Boulevard. In 1906, Broadway Boulevard was extended farther south to Westport Road and joined with Mill Creek Parkway. At the north end of the park, the drive connected to West Pennway, which connected to West Terrace Park near downtown. (Courtesy of BPRC.)

One

GULLY TOWN

Like most early river towns, Kansas City was a rough and unattractive place. Houses along the river lay against the bluffs, leaving very little room for expansion without climbing the perpendicular slopes. Ravines gouged their way through the bluffs, dumping a torrent of mud and water on the inhabitants below. Rickety bridge structures were used to cross these gorges. Open cesspools captured the runoff from human and animal waste. The city began to cut streets through the bluffs connecting the city to higher ground.

The coming of the train to Kansas City moved the center of business off the levee along the Missouri River and onto the floodplain bottomland between the bluffs and the confluence of the Kansas (Kaw) and Missouri Rivers. Saloons, blacksmith shops, and slum dwellings were the first things that greeted passengers stepping off the train in the West Bottoms. Poor laborers, mostly Irish or black, inhabited these gully and hillside slums. On top of the bluff were the upper-class Quality Hill homes. A funicular connected the two parts of town.

The unsightly views, the unsanitary living conditions, and the constantly muddy city streets were all reasons that civic leaders began to consider improvements to their city.

Kansas City was founded on the south bank of the Missouri River at a natural rock landing. The settlement was nestled along the shore between the river and the towering bluffs covered with timber and underbrush. In the early 1850s, the river was the center of community life. (Courtesy of MVSC-KCPL.)

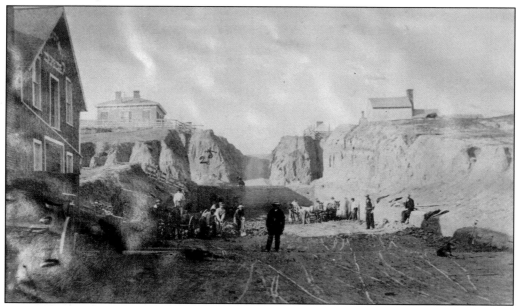

Walnut Street was impassable because of the steep grade until nearly 1870. A cut of 40 feet through solid rock was made at Seventh and Walnut Streets. This 1868 view of Walnut Street from Third Street north toward Second Street shows how drastically the topography was being changed. There were no condemnation damage awards. The work was done, and the property owner accepted the consequences. (Courtesy of MVSC-KCPL.)

Four gullies through the bluffs were the only accesses to the Missouri River from the south. As the town grew, it cut through the bluffs at other locations to obtain access to structures on higher ground. Grading Wyandotte Street to the river in the early 1870s was part of the city's first big program of street development. (Courtesy of MVSC-KCPL.)

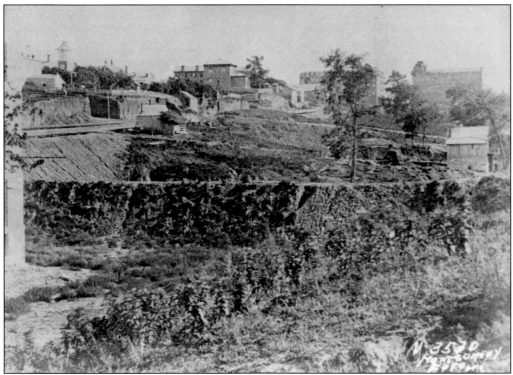

This 1870 photograph is looking southeast toward what appears to be Broadway running up to Tenth Street (upper right). The Coates House Hotel (1868) is on the east side of Broadway, and the Coates Opera House (1870) is on the west (right) side. A luxurious neighborhood for the wealthy, Quality Hill, grew up around the opera house and the hotel. (Courtesy of MVSC-KCPL.)

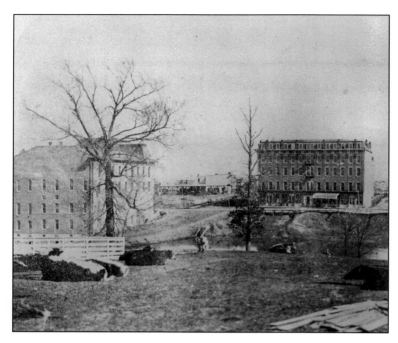

This is another early view of the Coates Opera House and the Coates House Hotel. The location is Tenth Street and Broadway. The date is 1871. Theatergoers had to ride carriages or walk on muddy, unpaved roads through pastures to reach the Coates Opera House. Notice the pool of standing water from agricultural and street runoff in the middle of the frame. (Courtesy of MVSC-KCPL.)

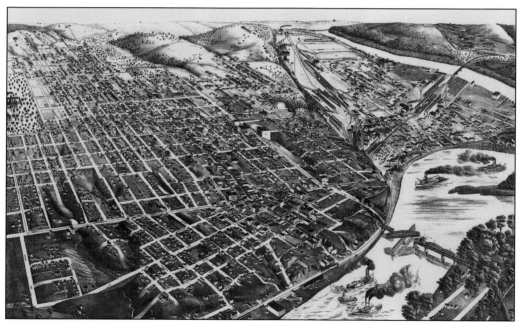

This 1878 view of Kansas City, looking southwest, shows the street grid laid out with little thought for the topography. Quality Hill overlooks the West Bottoms. The northward bend in the Missouri River is at center right, with the Kaw (Kansas) River at upper right. The first railroad bridge (Hannibal, 1869) across the Missouri River is at lower right. (Courtesy of MVSC-KCPL.)

An attractive business in Kansas City between 1870 and the 20th century was real estate. The population rose from around 25,000 in 1870 to 55,000 in 1880 and to about 125,000 in 1890. However, the real estate boom and city topography left pockets of substandard houses throughout the city. This 1878 photograph shows a part of Kansas City known as Happy Hollow, near Ninth and Holmes Streets. (Courtesy of MVSC-KCPL.)

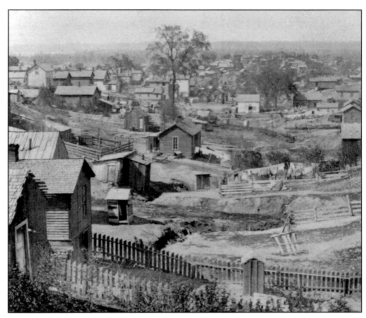

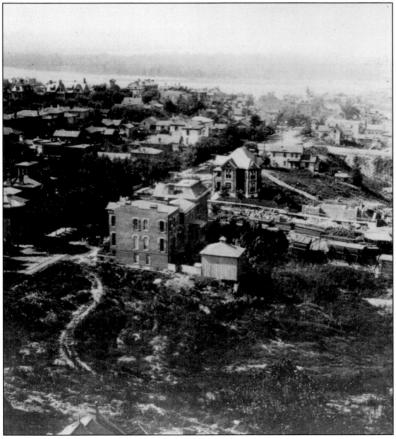

In 1880, the highest point in the city was the Immaculate Conception steeple on Eleventh Street west of Broadway. This 1890 photograph looks northwest toward the West Bottoms and the confluence of the Kansas and Missouri Rivers. Even in this well-to-do neighborhood, back yards dropped into ravines, and rough vacant lots made building difficult and allowed for the possibility of temporary shacks to pop up. (Courtesy of MVSC-KCPL.)

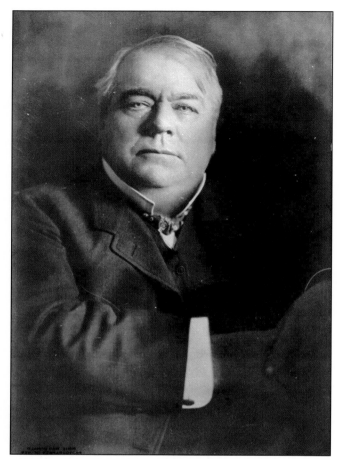

William Rockhill Nelson (1841–1915), one of the largest civic improvement boosters, arrived in Kansas City in 1880. He was 39 and from Indiana, where his father was known for his nursery and showplace estate. Nelson had been admitted to the bar and had been a political campaign manager and a building contractor, among other occupations. In partnership with Samuel E. Morss, he founded the *Kansas City Evening Star*. The first issue appeared on Saturday, September 18, 1880. He bought the *Kansas City Times*, a morning paper, in 1901. The crusading editor, through his paper, would become one of the most vocal and effective backers of the efforts in Kansas City to adopt an all-encompassing parks and boulevard system. The photograph below shows the *Star* office at Eleventh Street and Grand Avenue. (Courtesy of MVSC-KCPL.)

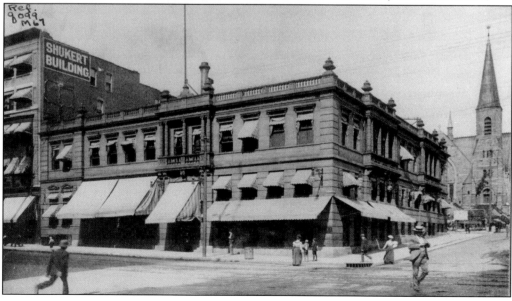

Kersey Coates's affluent Quality Hill district of the 1870s on the west bluffs attracted many leading citizens. Only brick houses were allowed on Quality Hill. Unfortunately, noisy railroads and smelly packinghouses in the neighboring West Bottoms were upwind of Quality Hill, reducing its desirability. This 1890 photograph shows the residence of James L. Lombard at 1805 Jefferson Street on Quality Hill. (Courtesy of MVSC-KCPL.)

In 1887, Nelson purchased land east of Westport town. When he could not persuade Kansas City to build a road to his development, he persuaded Westport to construct Warwick Boulevard to the Kansas City limits. The Samuel Jarvis home on the right faces Warwick Boulevard. The Alfred Toll residence at center sits on the southwest corner of Thirty-sixth Street and Warwick Boulevard, seen in the 1880s. (Courtesy of MVSC-KCPL.)

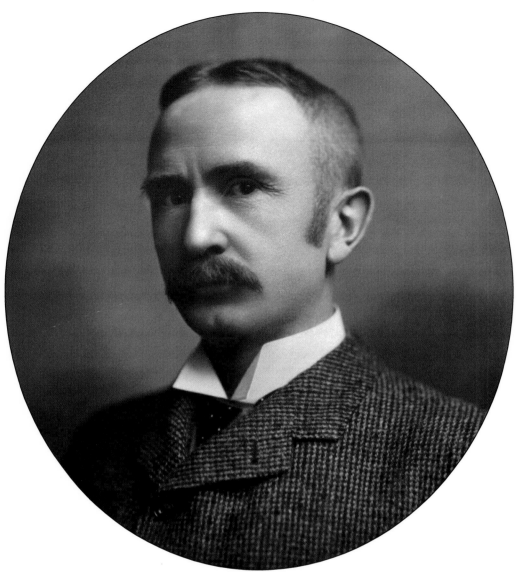

Originally from St. Louis, August Robert Meyer (1851–1905) was educated in Europe. He became a successful mining and smelting magnate in Colorado. Moving to Kansas City in 1881, he became a leading advocate for urban parks. For Meyer, city beautification was imperative— "A community must attract with more than just tax concessions and columns of figures." In 1892, he became president of the Kansas City park and boulevard board. Even before named to the board, Meyer led the drive for the charter amendments that established the board. He wrote to other cities inquiring about their park systems. He traveled throughout the country and Europe gathering ideas. Meyer, along with George Kessler, wrote the 1893 Report of the Board of Park and Boulevard Commissioners. That report became the foundation for the Kansas City parks and boulevard system. Implementation depended on Meyer's leadership. In the early days of the park fight, he addressed civic groups, illustrating his talks with magic lantern slides, bantering with hecklers, and answering pointed questions. Kansas City's park system would not have succeeded without his efforts. (Courtesy of BPRC.)

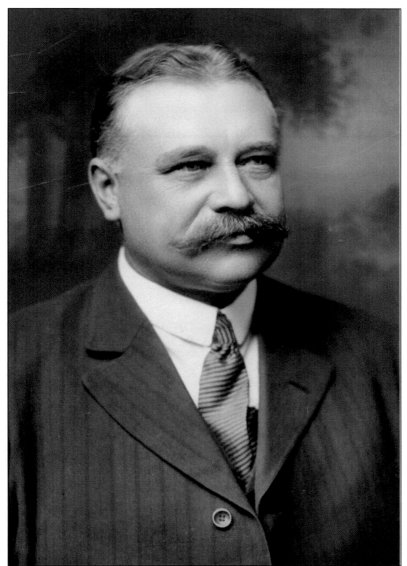

George E. Kessler (1862–1923), landscape architect and city planner, was educated in Europe. He arrived in Kansas City in 1882 to design a railroad company's excursion park in Merriam, Kansas. He opened a private landscape architecture office and soon was "beautifying" residential grounds, including August Meyer's estate on Independence Avenue. In 1892, the park board appointed Kessler secretary at a salary of $200 a month and board engineer with no pay. He occupied this dual position until 1902 and remained as landscape architect and adviser until his death. In the 1893 Report of the Board of Park and Boulevard Commissioners that he wrote with Meyer, Kessler exhibited an understanding of area topography and a love of nature. Kessler's plan preserved the streambeds and river bluffs that permeated the city. A continuous grand system of boulevards and parkways connected the city's parks and green spaces. His plans for Kansas City's park system established Kessler's national reputation as an important city planner and landscape architect. His skills gave character and individuality to many American cities in the early 20th century. (Courtesy of BPRC.)

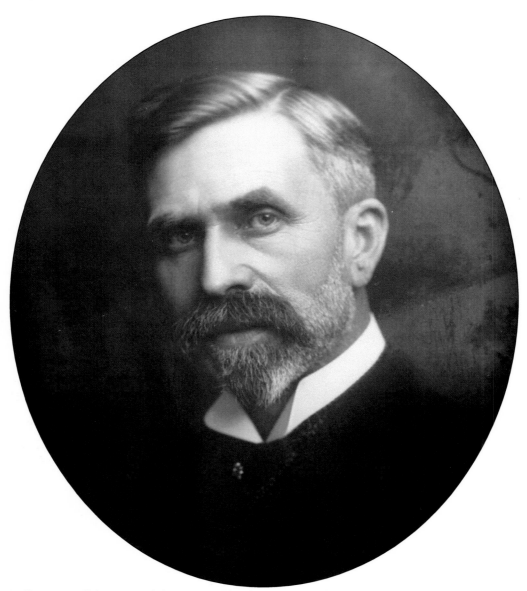

Delbert J. Haff (1859–1943), born in Oakland County, Michigan, came to Kansas City in 1886 to practice law. He helped organize the Municipal Improvement Association and served as the chairman of its park and boulevard committee. The first park board (1890) hired him to argue before the Missouri Supreme Court. That park law was declared unconstitutional. Haff then drafted the 1892 city charter amendment, which established the 1892 park board with August Meyer as president. In 1893, Haff became general counsel for that board. Haff devised the law in 1893 allowing the park board to collect special assessments for the improvement and purchase of parks and boulevards from nearby property owners. In 1895, he then drafted the companion charter amendment, allowing the park board to condemn or otherwise obtain land for park purposes. For several years, he defended the park laws against the suits of taxpayers and real estate owners. From 1909 to 1912, he served on the Board of Park and Boulevard Commissioners of Kansas City and was president in 1910 and 1911. (Courtesy of BPRC.)

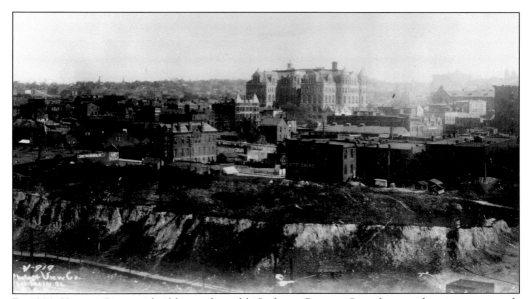

By 1890, Kansas City was building a formable Jackson County Courthouse of native stone with several turrets and a slate roof. It occupied a square block between Oak and Locust Streets and Fifth Street to Missouri Avenue. This photograph, looking to the south, shows that large expanses of the river bluffs and the central business district had still not been graded or developed. (Courtesy of MVSC-KCPL.)

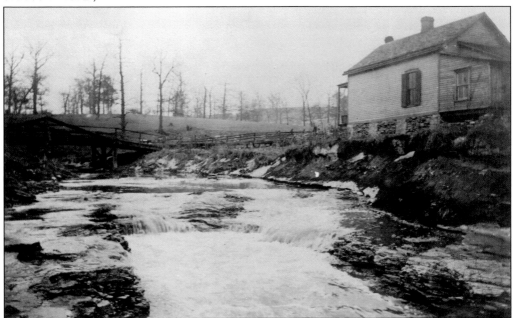

O. K. and Goose Neck Creeks run east and west; O. K. Creek drained into the Kaw (Kansas) River, while Goose Neck Creek emptied into the Blue River. Their valleys divided the city into north and south sides. In 1889, O. K. Creek was an uninviting eyesore separating the developing south side from downtown. This photograph was taken near Twenty-first and Wyandotte Streets. (Courtesy of MVSC-KCPL.)

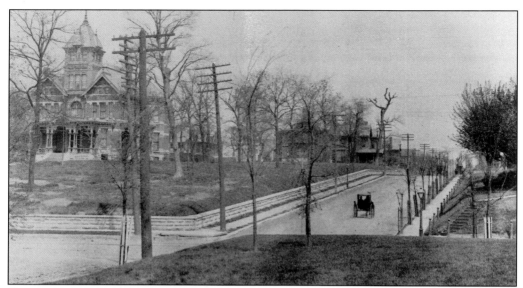

During the 1880s real estate boom, the primary direction of expansion was eastward. Pendleton Heights, the city's first suburb, was laid out in 1886 along Independence Avenue, the city's oldest east-west thoroughfare. It soon became the town's fashionable district with many Gingerbread mansions. In this c. 1890 photograph of Independence and Garfield Avenues, the only traffic is a horse and buggy. (Courtesy of MVSC-KCPL.)

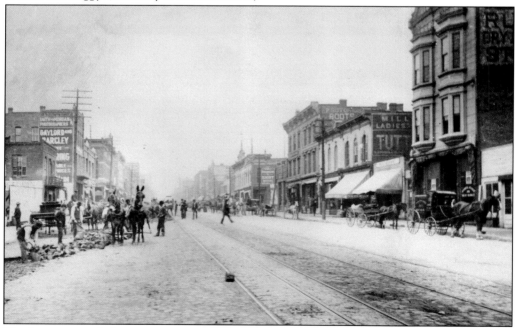

The horsecar made its appearance in 1879. A section of the first line ran from Eleventh Street to Grand Avenue and then south to Sixteenth Street, where the horsecar barn was located. An 1886 ordinance required stone or artificial stone sidewalks on main streets, replacing the wooden sidewalks of earlier years. This c. 1890 photograph looking north from Sixteenth Street shows the car tracks down Grand Avenue. (Courtesy of MVSC-KCPL.)

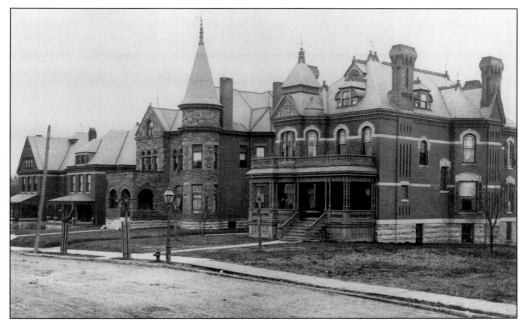

In 1886, the cable car line connected downtown to Woodland Avenue on the east via Independence Avenue. This growing ease of movement encouraged even more development to the east. Woodland Avenue was one of the several ridges suited for high-end residential development. Pictured here is a row of newly constructed homes around 1890 on Woodland Avenue. The address is unknown, but it is most likely in Pendleton Heights. (Courtesy of MVSC-KCPL.)

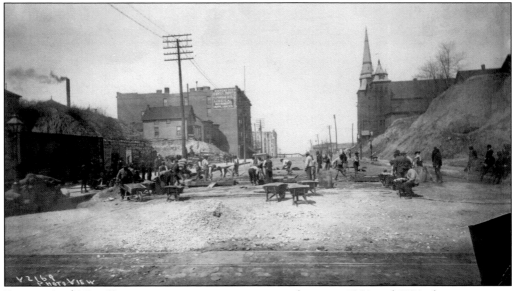

Despite the $1.5 million spent on street improvements between 1864 and 1874, the streets were still a mess. Much of the early pavement was of cheap quality, requiring frequent replacement. In the late 1880s, a newer paving process began replacing wooden block and cobblestone streets. Grand Avenue appears to be getting a full replacement in this 1900 photograph. (Courtesy of MVSC-KCPL.)

In 1893, Meyer and Kessler prepared the Report of the Board of Park and Boulevard Commissioners. This report embraced recommendations for the establishment of a park and boulevard system for Kansas City. The report recognized the challenge of the steep hills and river bluffs and the creek beds and gorges, which had given early city developers so many problems. Kessler, as a landscape architect, saw the difficulties as aesthetically pleasing assets. The report proposed improvements to the blighted west bluffs, a park on the north bluffs, and a large landscaped park on the broken and ugly Penn Street ravine in the southwestern part of the city. These three major parks were to be supplemented and connected by boulevards, playgrounds, and a grand formal boulevard, The Paseo. The comprehensive report also extended part of the system outside the city limits. The report recommended 9.85 miles of boulevards and 318.4 acres of parks and pleasure grounds. (Courtesy of MVSC-KCPL.)

Two

THE BOULEVARDS

In the 1909 Report of the Board of Park Commissioners, George Kessler wrote, "The system presented in 1893 may be considered properly in two divisions, boulevards and parks. These divisions, however, were inseparable. It was not contemplated that Kansas City should have boulevards without parks or parks without boulevards."

Five boulevards were constructed and extended—Independence (Independence and Gladstone), East (Benton), South (Linwood and Armour), Grand (Broadway), and The Paseo. On the north side, Independence Boulevard followed Independence Avenue for 0.76 mile, then turned north on Gladstone Avenue to St. John. It then curved away from St. John, following the ravine edge to Scarritt Avenue before turning east on Scarritt to the city limits. The East Boulevard basically followed the street grid, with a few bends, from Gladstone Boulevard to the South Boulevard. This route was chosen for its gentle grade to higher and slightly abutting lands and because there were few houses blocking the route. Because of considerable development outside the city limits and the certain growth of the city to the south, a South Boulevard (Linwood and Armour) was also proposed. This route was entirely outside the city limits. The outer boulevard system was completely connected with the adoption of the Penn Street ravine as a park along with a connecting boulevard (Grand/Broadway) running from the park to South Boulevard.

The width of boulevards, with few exceptions, would be 100 feet with a 40-foot-wide central roadway and 30-foot-wide "parking" on each side. The parking was to contain eight-foot-wide walkways and three rows of equally spaced trees. The idea was to give the boulevards a "park like" effect. As the trees matured, one row would be removed and replanted in other locations. The roadway width was expected to accommodate boulevard traffic for at least 20 years. With the advent of automobiles, it became clear that 15 years rather than 20 was the limit for some 40-foot boulevards. Several roads would unfortunately need to be widened at the expense of their park-like setting.

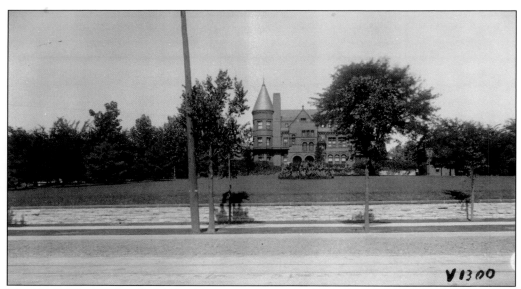

Wealthy residents were already building mansions east of downtown on Independence Avenue before the road was changed to a boulevard. The David Beals home (above) was one of the larger houses. It was located at 2506 Independence Avenue between Wabash and Prospect Avenues, three blocks east of Independence Plaza. Beals moved to Kansas City in 1884. He was the president of the National Bank of Kansas City and owned area property. One block west of Independence Plaza at 2114 Independence Avenue was the Churchill J. White residence (below). White came to Kansas City in 1865 and worked in the banking industry. He eventually became the president of Citizens National Bank. (Both, courtesy of MVSC-KCPL.)

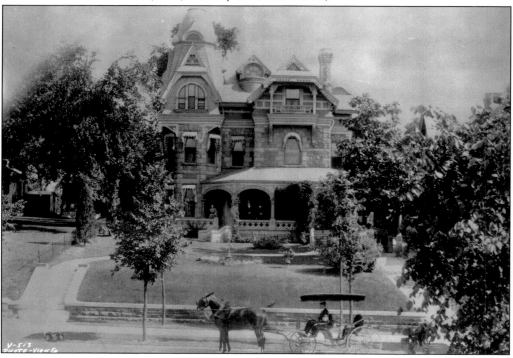

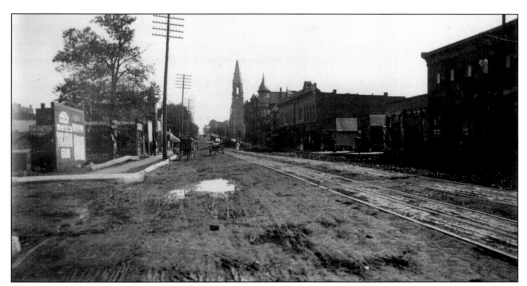

Several blocks of Independence Avenue were proposed as part of the 1893 north boulevard. The 1890 photograph above, looking east from west of Garfield Avenue, was taken prior to improvements. The Independence Avenue Methodist Church spire in the background is on the south side of the roadway. That spire can also be seen in the photograph below of the completed Independence Boulevard. The avenue was a major connector of Independence, Missouri, to downtown. Because of the heavy traffic, Independence Boulevard was the most expensive street to maintain. The extensive road dust that settled on the parking gradually raised the lawn parkings several inches above the grade of the walks and curbs. The original macadam roadway, shown here, was resurfaced with native limestone in 1906. By 1914, the boulevard was a commercial thoroughfare and was repaved with a bituminous macadam surface. (Both, courtesy of BPRC.)

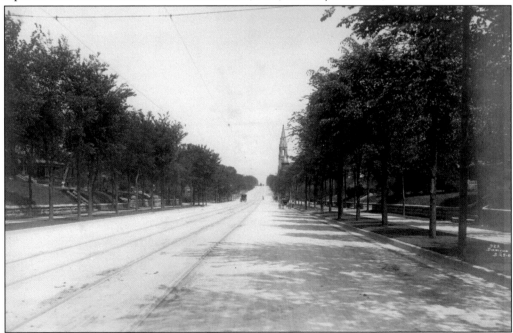

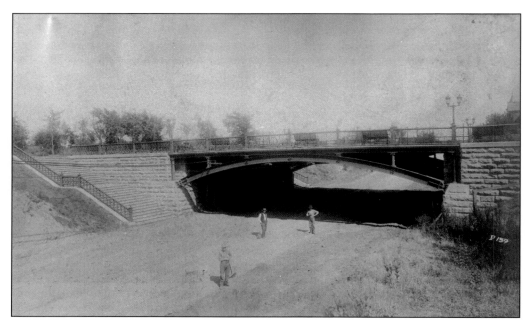

In order to connect the north-south section of Gladstone Boulevard with North Terrace Park, a bridge needed to be built over the east-west Anderson Avenue. The photograph above is of the completed bridge in 1898, and the one below shows Kansas Citians taking pleasure drives over Gladstone Boulevard Bridge at Anderson Avenue. Gladstone Boulevard turned east a block north of this bridge. The deep valley between Gladstone Boulevard, Benton Boulevard, and Anderson Avenue was filled with tons of earth from the bluffs to form The Concourse, a two-block level area with splendid views of the Missouri River. Gladstone Boulevard, The Concourse, and North Terrace Park became the city's favorite areas for a pleasure drive. (Both, courtesy of BPRC.)

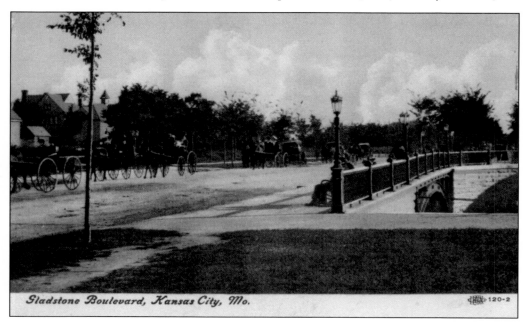

Gladstone Boulevard, Kansas City, Mo.

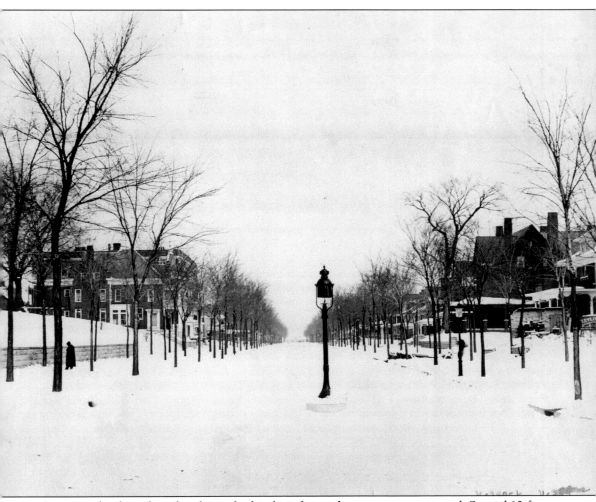

Living on boulevards and parkways had its benefits, and one was snow removal. Special 10-foot-wide blades were attached to ordinary road graders to remove street snow. An 18-foot-wide strip could be cleared in two passes down the street. An A-shaped, six-foot-wide wooden plow was for sidewalks. It was pulled by two horses and controlled by three men. One man drove the horses and the other two lifted the plow up and down at curbs. Four men followed, shoveling the intersecting sidewalks and approaches to residences. The natural gas lamp pole in the middle of the roadway was fitted with Welsbach heads and an exterior globe of ruby glass. These were used at boulevard intersections to regulate vehicle and pedestrian traffic. This photograph looks north along Gladstone Boulevard from Independence Boulevard before the snow was plowed. (Courtesy of MVSC-KCPL.)

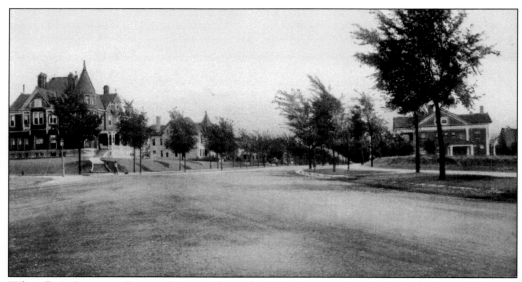

When R.A. Long saw Scarritt Point in the early 1900s, he wanted a whole block along Gladstone Boulevard to build his mansion and extensive grounds. He purchased two houses on the left of this postcard and had them moved. The white stone house was moved diagonally across the street and still stands. The turreted, redbrick house was moved one block north, and the exterior was extensively changed. (Courtesy of MVSC-KCPL.)

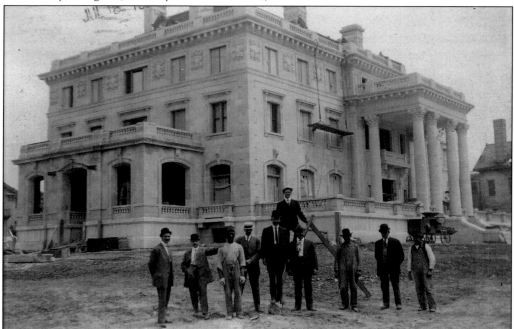

R.A. Long, a lumberman, named his Beaux-Arts mansion Corinthian Hall after the six Corinthian columns on the front portico. It took two years to build. The mansion's 35,000 square feet contained 72 room and 15 baths and served as the family home until Long's death in 1934. The garage contained the generating plant for the property and the chauffeur's family residence. (Courtesy of KCM-US.)

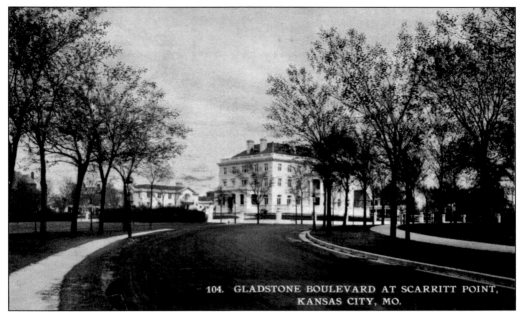

104. GLADSTONE BOULEVARD AT SCARRITT POINT, KANSAS CITY, MO.

Henry F. Holt designed Robert Alexander Long's house in 1908. The estimated cost was $1 million. The grounds contained a gatehouse where the horse trainer's family resided. There was a barn with horse stalls and servant quarters, a greenhouse, a conservatory, and a pergola. The home is on Gladstone Boulevard where it turns east. This view is the same as the postcard on the facing page. (Courtesy of MVSC-KCPL.)

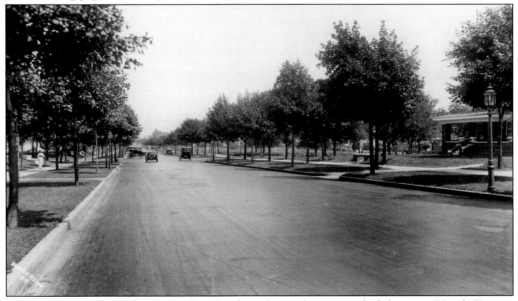

Benton Boulevard, first known as East Boulevard, was the eastern link between North Terrace Park and south Kansas City. The section from Independence Avenue to Thirty-first Street was acquired in 1896 and the section from Thirty-first Street to Linwood Boulevard in 1899. Shortly after completion it was renamed for Thomas Hart Benton, a famous Missouri senator. This photograph, taken around 1910, is looking north from Thirtieth Street. (Courtesy of BPRC.)

Armour Boulevard, the western leg of the 1893 planned South Boulevard, was constructed over what had been Commonwealth Avenue. The boulevard was acquired in 1899. One of the first members of the Board of Park and Boulevard Commissioners of Kansas City, S.B. Armour, of Armour Packing Company, died in 1901. To commemorate his memory, the section of South Boulevard between The Paseo and Broadway was named for him. Several relatives of S.B. Armour lived on the street, but at his death, he lived on Quality Hill. The photograph above is of Armour Boulevard looking west to the Harrison Boulevard intersection. The 1907 photograph below is looking east from Broadway Boulevard. (Both, courtesy of BPRC.)

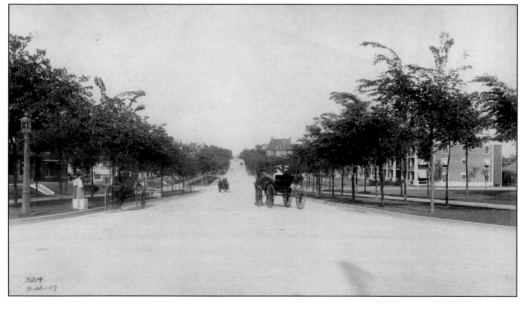

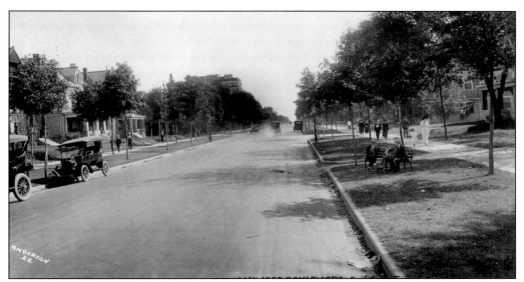

Linwood Boulevard is the eastern leg of the 1893 planned South Boulevard. The original boulevard, acquired in 1899, connected Benton Boulevard and Troost Avenue. Linwood follows the ridge between O. K. Creek and Brush Creek. The boulevard was an excellent example of the standard 100-foot boulevard recommended in the 1893 Report. The 40-foot roadway was lined with three rows of trees and a wide walking path. The c. 1910 photograph above is looking east from Forest Avenue. The view below is looking west from The Paseo. Eventually, Linwood Boulevard was extended east to Van Brunt Boulevard in 1915, farther west to Gillham Road via Thirty-second Street in 1900, and finally from Gillham Road west to Broadway Boulevard in 1926. (Both, courtesy of BPRC.)

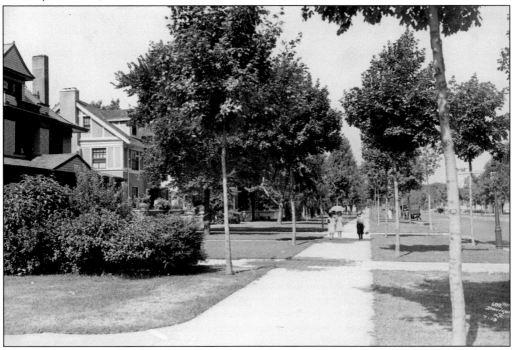

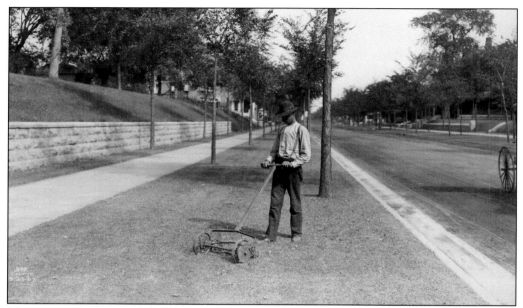

Maintaining the beauty of the boulevards and parks required an army of gardeners and maintenance workers. Every 22-foot-wide parking needed mowing. In 1909, the daily wages for park laborers was increased from $1.75 to $2.00. This view looks north on Gladstone Boulevard from Independence Boulevard. The date is 1907. (Courtesy of BPRC.)

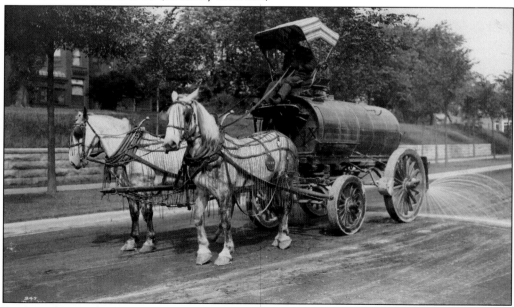

Boulevards were first watered to reduce dust. As traffic and speed increased, oil became a more effective and cheaper method. After many complaints from boulevard residents tracking the sticky oil into their homes, the parks department provided dry places for people to cross the freshly oiled streets. This 1907 photograph on Gladstone Boulevard shows a well-equipped water sprinkling wagon. The fringe protects the horses from flies, and a shade protects the driver from the sun. (Courtesy of BPRC.)

Three

THE PLEASURE GROUNDS

Three pleasure grounds (large parks) were proposed in the 1893 Report of the Board of Park and Boulevard Commissioners. They were North Terrace, West Terrace, and Penn Valley. These parks provided "country scenes and clear fresh air" for all the city's residents. The parks, planned on the outskirts of the city, were to be accessible by everyone. All three parks had the typical rugged topography of the city. Two parks were wild, rough land more attractive for parks than anything else. And two parks had shanties and slums spreading on their hillsides. All three had the possibility of beautiful scenic views. All three were also the subject of opposition and lengthy court battles.

By 1920, North Terrace Park contained 305.44 acres and 8.06 miles of completed scenic drives. The secluded Cliff Drive meandered through the length of the park. Scarritt and Prospect Points on opposite sides of a deep canyon provided panoramic views of the Missouri River and the distant Clay County hills. A broad intersection of boulevards with open lawn and a beautiful colonnade structure formed the setting of a third outlook. Acquisition cost was $1 million, and construction was almost half a million dollars.

West Terrace Park was along a row of rough limestone ledges overlooking the Union depot and the Kaw (Kansas) River. The 33.41-acre park extended from Sixth to Seventeenth Streets. Kersey Coates Drive ran along the bluffs for 1.18 miles. The park presented half a dozen views of the railroad yards, the packinghouses, the stockyards, and the industrial landscape on both sides of the Kaw River. The long, narrow West Terrace Park contained a massive stone outlook with retaining walls, several sets of stone stairs, and two playground sites.

Penn Valley Park, a rugged, picturesque park, was near the southern edge of downtown. The old Santa Fe Trail split the 131.92-acre park. A system of drives provided panoramic views of downtown and the west side. The park contained a lake, tennis courts, field house, swimming pool, three separate children's playgrounds, and baseball diamonds. Acquisition cost was $870,760.

City officials touring the North Terrace Park site were not impressed. One declared the project impossible. He went on to say, "A goat could not climb along where it was proposed to lay out the drive." Another official referred to this location as "a squirrel pasture." This 1894 photograph shows "The Wilderness" below Will Scarritt's house. (Courtesy of BPRC.)

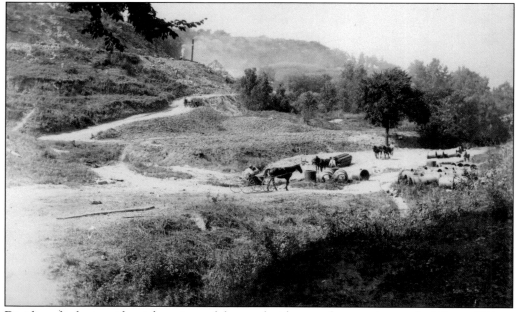

Dividing the best residential sections of the north side was a large ravine to the Missouri River. The main west plateau was Scarritt Point, with steep picturesque limestone cliffs. West of the ravine was Prospect Point. Both points had magnificent views. This early 1900s view is of the dam construction, which created a lake in the ravine. (Courtesy of BPRC.)

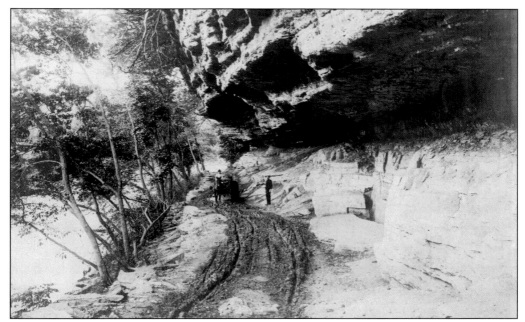

The area east of Scarritt Point contained a jumble of precipitous limestone crags. An old quarry road clung to the limestone face about halfway down the hillside. This road furnished the suggestion for a drive along the face of the bluff wedged between the cliff and timberline. This 1903 photograph shows the beginnings of Cliff Drive. (Courtesy of MVSC-KCPL.)

A spring was a major obstacle during construction of Cliff Drive. The park board considered sealing it, but the purity of the water made them reconsider. From the day Cliff Drive opened, people lined up to fill jugs and bottles at the large shell-shaped stone bowl specially carved for the site. In hot weather, the spring became so popular that attendants had to speed things along. (Courtesy of BPRC.)

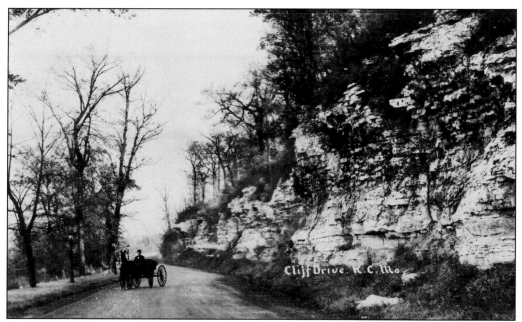

An impromptu gathering celebrated the opening of the wilder western section of Cliff Drive in July 1905. The not-so-challenging eastern section was completed in 1900. The 3.5-mile-long Cliff Drive was designed for horse-drawn conveyances. Since not everyone could afford such transportation, the city purchased a team of horses and "wagonettes," and during the summer of 1905, charged 25¢ for a round-trip ride. Because of the contours and narrowness of the Cliff Drive, the roadway was one-way for its first 20 years. The photograph above shows a buggy going east on Cliff Drive. The Scarritt Point entrance to Cliff Drive is shown below. (Above, courtesy of MVSC-KCPL; below, courtesy of BPRC.)

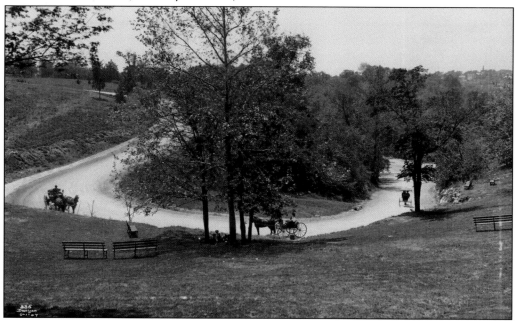

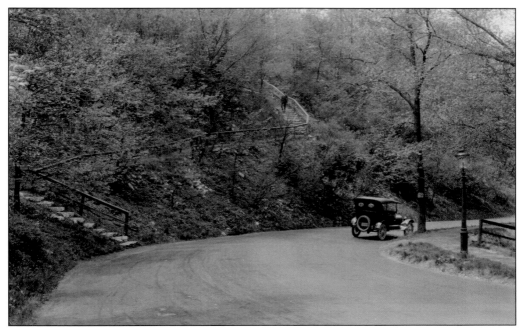

In multiple locations, stairs connected the top of North Terrace Park to Cliff Drive. The plateaus of North Terrace Park provided numerous opportunities for quiet pastimes in natural settings with views of the industrial East Bottoms, the river, and Clay County. Automobiles were first allowed on Cliff Drive in 1910, but only on Sundays. It was a dangerous road. The first serious accident occurred in the winter of 1910. A red Pierce-Arrow inching along at eight miles per hour slid off an icy curve below Scarritt Point. It ended up upside down in a boulder-strewn ravine, killing three adults. (Both, courtesy of BPRC.)

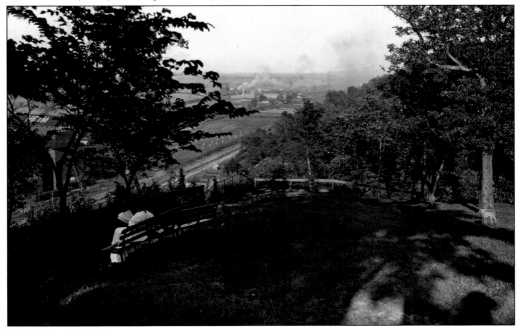

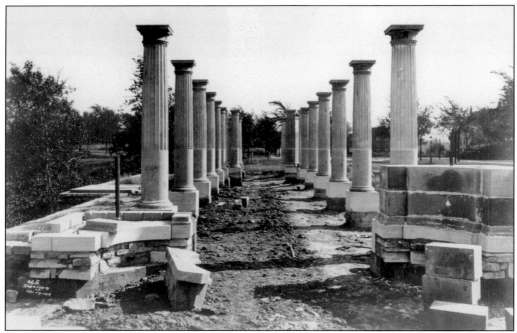

The Colonnade with pergolas is located at the north end of Gladstone Boulevard where the road follows the bluffs of North Terrace Park. Located between the large ravine (Chestnut Avenue) that divided the two sections of North Terrace Park, The Colonnade provided views of Cliff Drive, Scarritt Point, Prospect Point, the major ravine, the East Bottoms, and the Missouri River. Conflicting credit for The Colonnade design goes to architect Henry Wright and John Van Brunt. Construction was completed in 1908. (Above, courtesy of MHM; below, courtesy of BPRC.)

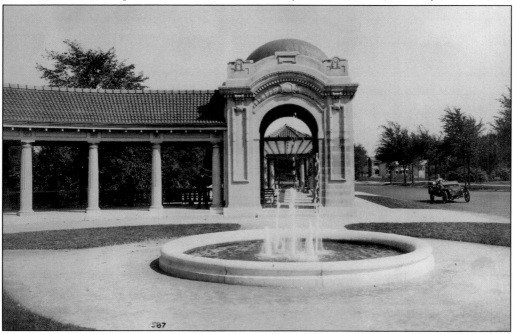

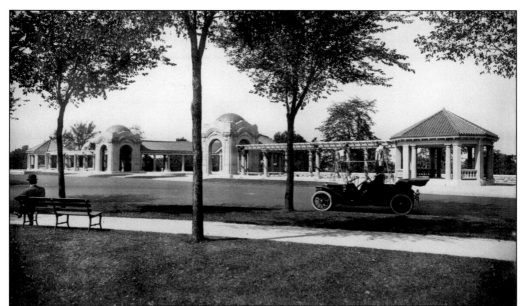

The Colonnade consists of two pavilions connected by a semicircle colonnade. The two pavilions are flanked by two 63-foot-long pergolas, lined with benches ending in music stands. The central focal point of The Colonnade was a fountain designed by Henry Wright in 1908. The outer retaining wall and steps to Cliff Drive, pictured at right, were constructed by park labor. (Both, courtesy of BPRC.)

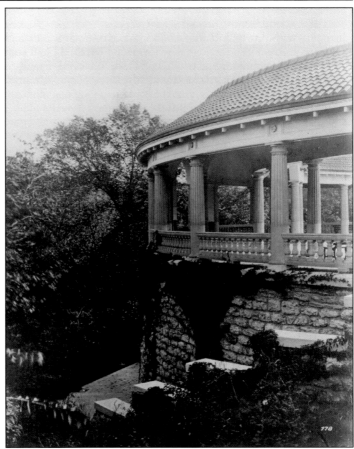

The large ravine between Scarritt and Prospect Points was turned into Chestnut Avenue Canyon. The canyon contained Chestnut Avenue, a lake, and two bridges. One bridge went under Cliff Drive. Chestnut Avenue connects Independence Boulevard to the East Bottoms. The high cliffs in the left photograph show the depth of the ravine. (Both, courtesy of BPRC.)

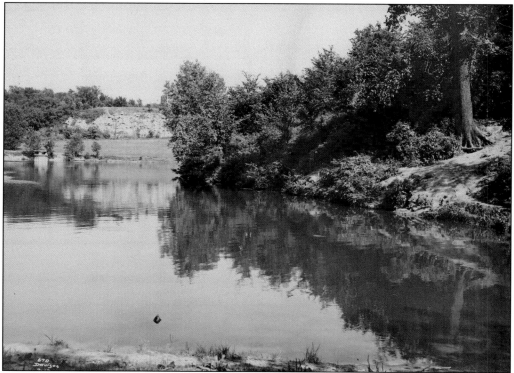

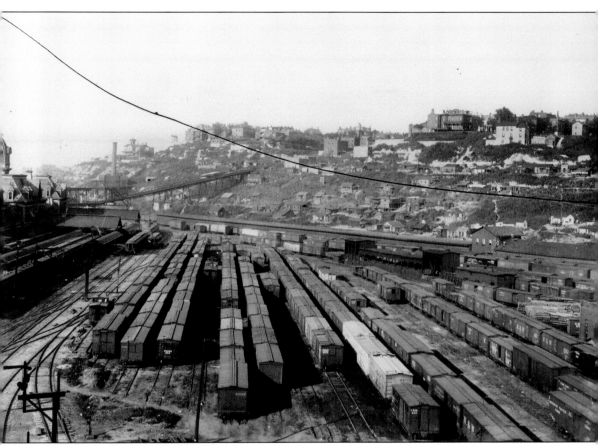

The construction of the Hannibal Railroad Bridge over the Missouri River in 1869 was driven by a need for rail yards in the West Bottoms to serve the stockyards and meat packers, and a passenger train depot. In 1878, the massive, 384-foot-long Union depot (left center), with its 125-foot, four-sided clock tower, was constructed on land bought from Kersey Coates. The west bluffs of Kansas City, overlooking the confluence of the Kaw (Kansas) and Missouri Rivers, were just as formidable as those on the north side of town, but with the arrival of the rail yards and depot, they quickly became one of the uglier parts of Kansas City. Tumble-down shanties, reached by paths that wound precariously in and out among rocks and bushes, were sprinkled along the hillside. Traveling from the depot to the hilltop and downtown involved a nerve-racking ride on the cable cars of the steep Ninth Street Incline. The smoke of the coal-fired trains coated nearby buildings with black soot. (Courtesy of WAP.)

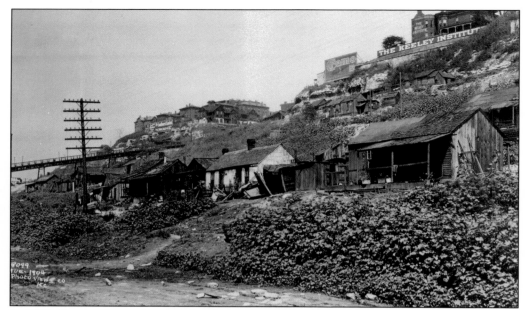

In 1855, Kersey Coates bought the elevated and beautiful west bluffs with the intention of developing a subdivision, Quality Hill, for richer Kansas City residents. By 1904, many brick mansions had been built atop the bluff, but the hillside was awash with shanties and billboards. The Keeley Institute, at 716 West Tenth Street, was a sanitarium "for the cure of liquor and opium addictions." (Courtesy of BPRC.)

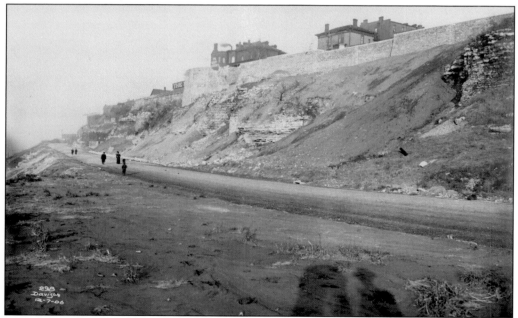

By 1906, the hillside below Ninth and Tenth Streets was cleared, the bluffs were groomed, and a massive stone retaining wall was built. Kersey Coates Drive was graded at the bottom of the bluff as part of North Terrace Park. The Keeley Institute is just visible at upper left. (Courtesy of BPRC.)

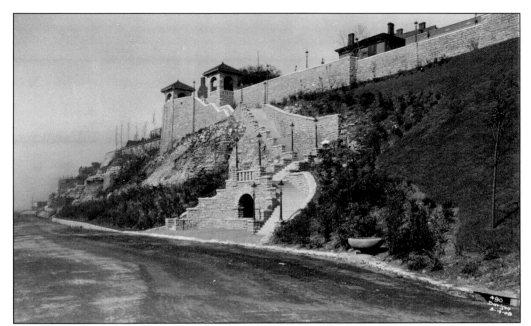

By 1908, Kersey Coates Terrace from Sixth to Twelfth Streets was complete with landscaping. Elaborate stone steps, walls, and terraces connected the Outlook Tower at Tenth Street to the grotto with a fountain on Kersey Coates Drive. A water bowl for horses is to the right of the grotto. This photograph is of the same hillside as both pictures on the facing page. (Courtesy of BPRC.)

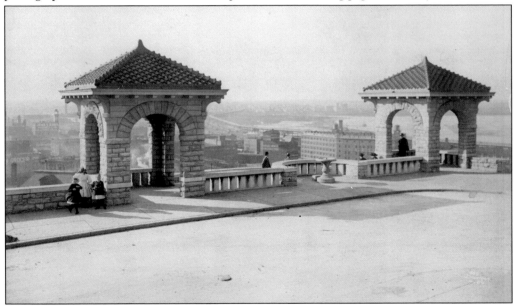

What would become known as the Outlook Tower was composed of two towers with a semicircle terrace and fountain between them. In 1908, the stone retaining wall was extended 200 feet to the north. The outlook provided a broad panoramic view of the railroad terminals, livestock yards, and factories in the West Bottoms, with Kansas City, Kansas, on the hills beyond the Kaw (Kansas) River. (Courtesy of BPRC.)

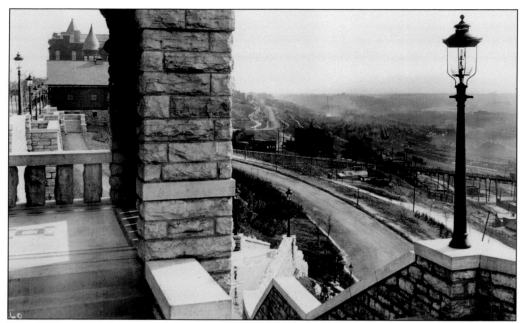

This 1915 view is from the south tower of the outlook at Tenth Street. It is looking southwest. The street on the left is Summit. The hillside road and park at top center is the continuation of West Terrace Park to Seventeenth Street. The construction of the Twelfth Street Bridge can also be seen. (Courtesy of MVSC-KCPL.)

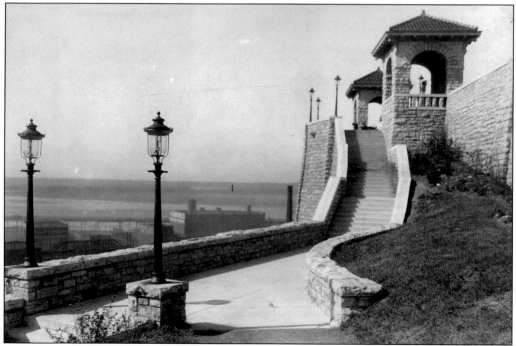

This view of the Outlook Tower is from the first terrace, looking up and northwest toward the rivers. (Courtesy of BPRC.)

This 1886 photograph shows the new construction at Eleventh and Summit Streets on Quality Hill and the shanties below on the hillside. The first Twelfth Street Viaduct, under construction in the foreground, was an iron structure designed for cable railway and pedestrian traffic. A new double-deck, 2,300-foot-long reinforced concrete viaduct replaced the dilapidated Twelfth Street cable car trestle in 1915. The new viaduct was designed to carry 20th century vehicular traffic between downtown and the West Bottoms. (Courtesy of MVSC-KCPL.)

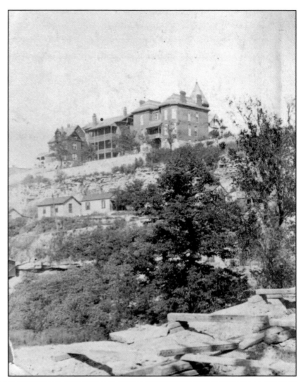

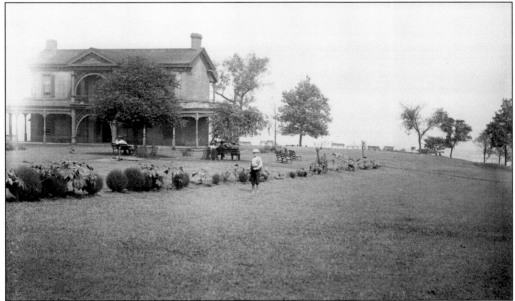

William Mulkey married Catherine Dripps, daughter of a mountain man and Oto Indian woman. Prior to 1860, Mulkey built a house on his wife's land. In 1869, he platted the land from Thirteenth to Sixteenth Streets. In 1882, the Mulkeys presented a tiny triangle of land to the city for its first permanent public park. The old Mulkey homestead, pictured here, became part of West Terrace Park. (Courtesy of BPRC.)

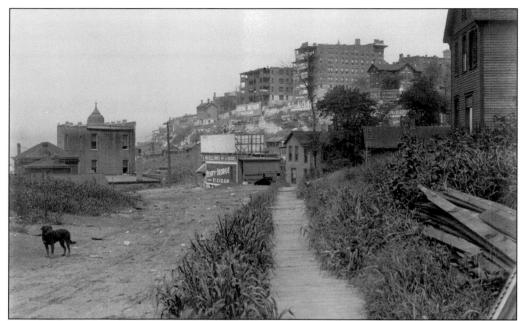

The 1904 photograph above shows the west bluffs, looking north from approximately Thirteenth Street. By then, most of the houses on top of the bluff were converted into rooming houses or rental property for an increasingly transient population. By 1909, this section of West Terrace Park was improved. Kersey Coates Drive was finished, the ground had been cleared, and the walks and stone stairs were completed. Looking north toward the Twelfth Street Viaduct, the 1921 photograph below was taken from Fourteenth Street. Only the upper deck of the viaduct is visible. The statue of Pendergast is in the middle of the frame. There were several stairs leading from the upper level to Kersey Coates Drive. (Both, courtesy of BPRC.)

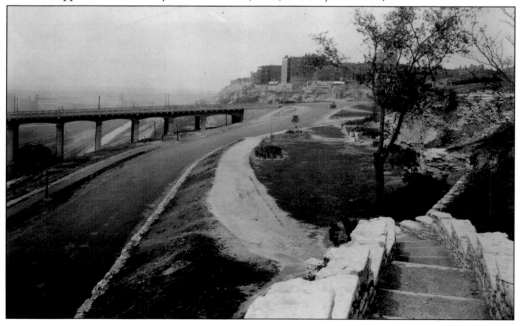

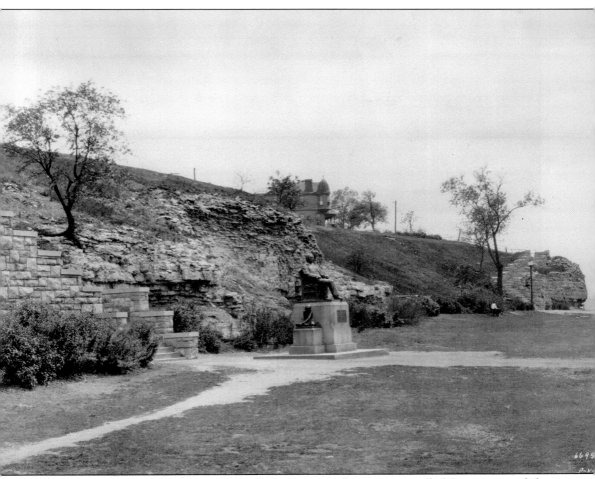

The political boss and alderman James F. Pendergast, who everyone called Jim, supported the public improvements movement. More boulevards and parks meant more jobs for his constituency. In 1913, a statue of Pendergast was placed in Mulkey Square near the west end of Thirteenth Street. It overlooked the West Bottoms where Pendergast had been the poor man's saloonkeeper and a friend to all. He opened the Climax Saloon with horse race winnings on a long shot named Climax. "Big Jim" served 18 years as alderman and played a "hard game of spoils politics," according to the *Kansas Times*. From approximately 1925 to 1939, his younger brother Thomas J. Pendergast became the most infamous and crooked politician in Kansas City history. "Boss Tom" never held a political office, but he got workers jobs and politicians elected. The park and boulevard system was established and expanded with the aid of political bosses who delivered the necessary votes—for a price. (Courtesy of MVSC-KCPL.)

By 1915, Kersey Coates Drive (West Cliff Drive) had been completed north of Sixteenth Street. (Courtesy of BPRC.)

Seventeenth Street was the southern end of West Terrace Park. This park area was the former West Prospect Park, the first city park donated by the Mulkey family. A shelter house with pergola, restrooms, and bathhouse was built in 1914. A combined wading pool and swimming basin was constructed northwest of the shelter house in 1920. West Pennway connected West Terrace Park to Penn Valley Park. (Courtesy of BPRC.)

The future Penn Valley Park was a deep ravine with 300 houses scatted on its hillsides. None of the structures cost over $2,000, and many cost little more than $100. A few unpaved streets meandered through the settlement, and boardwalks dipped and rose as they followed the rugged contours. In some places, the walks hung on wobbly stilts to give passage across the gullies. This photograph was taken around 1890. (Courtesy of BPRC.)

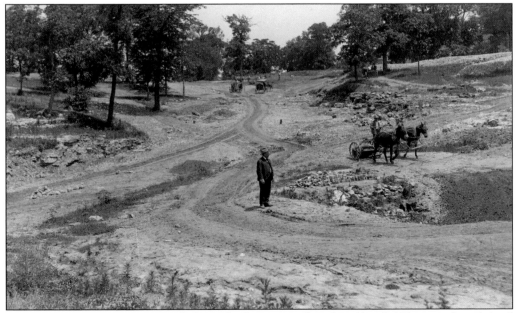

After the structures were removed, the parks department found itself with 130 acres of rough land and 100 or more holes that had been house cellars. Tons of dirt and rubbish were left behind from the moved or demolished houses. (Courtesy of BPRC.)

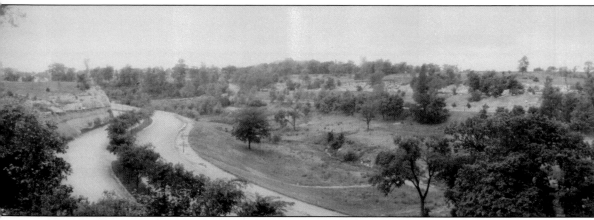

The 131.92-acre Penn Valley Park was bordered by Twenty-sixth and Thirty-first Streets on the north and south and by Wyandotte and Summit Streets on the east and west. An entrance extended to Main Street on the east. When acquired, transiting the ravine along Penn Street would have challenged a goat. This panoramic view from the ridge at approximately Twenty-ninth Street and Penn Valley Drive shows the park after being completed in1903. Gently graded drives were made

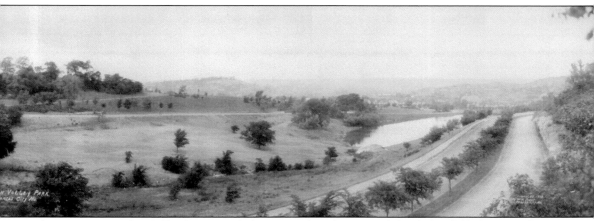

by cutting into the cliffs of stone and clay. Stone foundations stabilized the cliffs that rested on clay. The ravine was damned to create a lake. The summits of Penn Valley Park provided views of downtown Kansas City, of the O. K. and Turkey Creek valleys, and the Kaw (Kansas) River. (Courtesy of Library of Congress.)

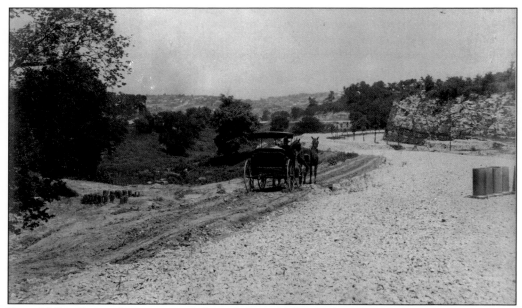

Penn Valley Drive, the major road through Penn Valley Park, followed the old Westport road connecting the downtown Missouri River levee and the town of Westport. This early photograph of Penn Valley Park shows the drive under construction. The horse-drawn buggy is heading north at approximately the same spot that the steps in the photograph below connect to the drive. (Courtesy of BPRC.)

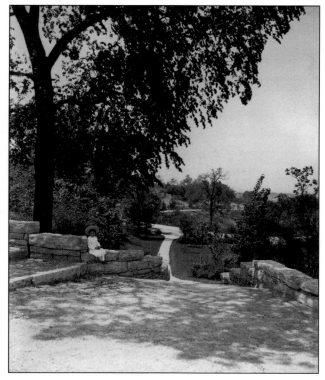

The high ground north of Thirty-first Street was connected by stone stairs, with one set of steps branching to the valley on the north and another set branching off to the east to connect to Penn Valley Drive. This photograph, looking northwest, was taken in June 1907 at the top of the stairs going down into the valley. (Courtesy of BPRC.)

Penn Valley Drive was a double roadway with one side for pleasure vehicles and the other for heavy traffic. Trees separated the two roads. Heavy wagons were only allowed on the east, heavy traffic road. At the southern end of the park, the heavy traffic was routed east onto Main Street. Walls of natural stone were built to support the cliffs. This 1907 photograph looks south at approximately Twenty-ninth Street. (Courtesy of BPRC.)

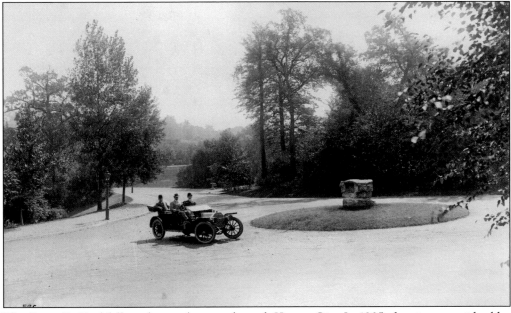

The Santa Fe Trail followed several routes through Kansas City. In 1905, the city met with older residents who had used the Santa Fe Trail and located four fragments of the original route. The Pierre Roi Road section of the trail went through Penn Valley Park. A granite and bronze plaque marker, pictured here, was placed at the southwest end of the valley. (Courtesy of BPRC.)

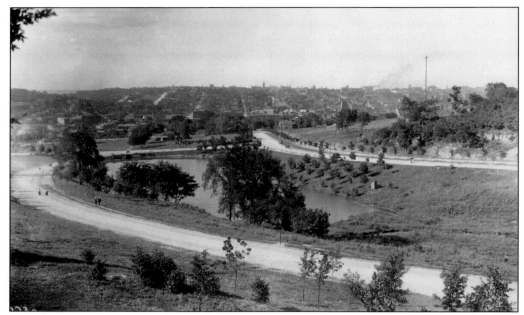

With the construction of a high earth dam at the northern end of the ravine, the surface water and water from a spring pouring into the valley formed a lake. Wagonloads of earth were dumped north of the dam to create grass-covered slopes. To regulate the amount of water in the lake, a four-foot, 1,000-foot-long sewer was constructed. With a turn of a valve, the whole lake could be emptied. Throughout the entire park were smaller underground water drains. All the water that passed into the park was carried away underground before it could do damage. Further improvements included wrought iron fences and benches. The photograph above was taken looking northeast toward the newly formed lake and Penn Valley Drive. The photograph below was taken looking south from the northwest corner of the lake. (Both, courtesy of BPRC.)

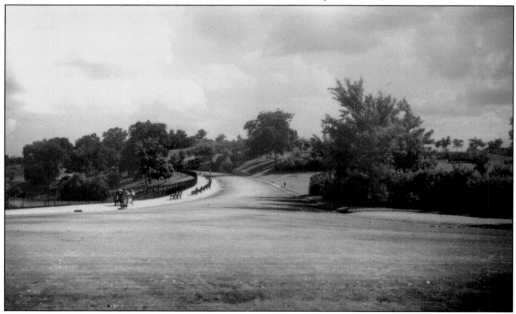

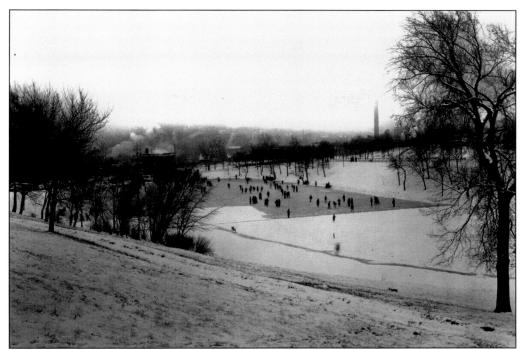

The Penn Valley Park valley was a winter playground. Crowds ice skated on the frozen lake and coasted down the snowy slopes. (Courtesy of BPRC.)

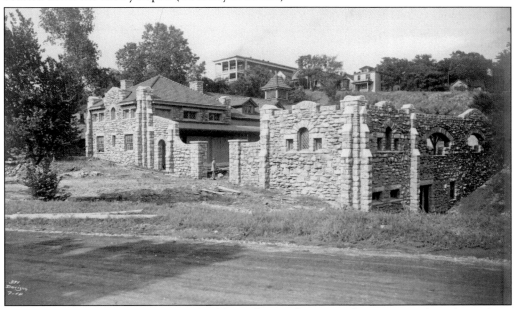

In 1910, a maintenance and storage building of natural stone and concrete with a tile roof was built in the southeast corner of the park. The Roots & Siemens architectural firm designed the $20,650 complex, pictured here. The park foreman's residence was established at this location, and the old maintenance building grounds at the northeast corner of the park became a playground. (Courtesy of BPRC.)

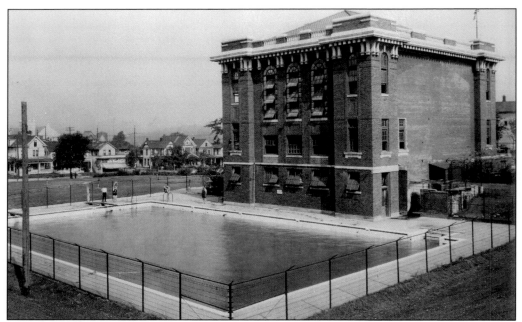

Ten acres at the northwest corner of Penn Valley Park were for playground activities. In 1910, a baseball diamond was installed. In 1911, the community urged the construction of a bathhouse because only 200 of the more than 1,300 houses west of the park had bathrooms. Plans were made for a central building with a shower and gymnasium wings and an outdoor pool. The central brick administration building and the 60-foot-by-120-foot swimming pool were built between 1914 and 1916. The brick building contained a large waiting room trimmed with marble and a large assembly hall. The basement level, opening to the pool, had lockers and showers. The pool was lined with white enamel brick. Rows of green bricks along the bottom provided lanes for races. The pool also hosted diving contests. (Above, courtesy of BPRC; below, courtesy of MVSC-KCPL.)

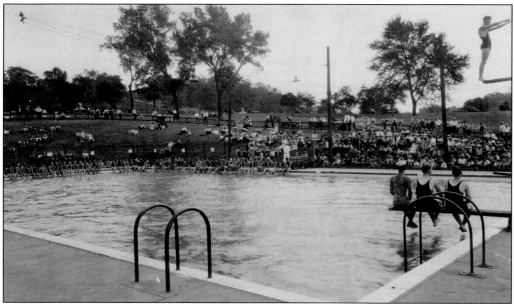

Four

THE PARADE AND THE PASEO

At the turn of the 20th century, every city needed open land for the drilling and parade of local military organizations, for large outdoor public gatherings, and for sports like baseball and tennis. The Gates and Kendall property, formerly circus grounds, was such an open space in Kansas City's difficult topography. The 18-acre site near densely developed areas was between Fifteenth and Eighteenth Streets and Flora and Woodland Avenues. The land for The Parade cost $142,500 in 1900. The centrally located park was planned as a fully equipped playground for summer and winter sports.

However, The Parade needed to connect to the new parks and boulevard system. To do that, Kessler's 1893 Report of the Board of Park and Boulevard Commissioners proposed turning the narrow city blocks between Grove and Flora Avenues running south from Ninth Street into a boulevard modeled on Drexel Boulevard in Chicago. This parkway would act as a promenade connecting The Parade to the entire boulevard system. The full width of The Paseo, including the two streets, was 223 feet in the section north of Twelfth Street and 242 feet south of Twelfth Street. The parking and street widths were to be that of the standard boulevards—30-foot parkings on each side, with three rows of trees and 40-foot roadbeds. This left a central median of 113 to 132 feet in width. In each median between the numbered east-west streets would be a succession of flower gardens with water features, structures, walks, and landscaping. The Paseo would be the only city park where residents could see beautiful flowers in abundance, artistically displayed. Also, travelers going to and from downtown would pass by these oases of urban planning.

The land south from Ninth to Seventeenth Streets was acquired in 1896 and 1897. The land connecting The Paseo from Ninth Street north to Independence Boulevard was acquired in 1897. By 1900, the land necessary to connect with Armour Boulevard on the south city limits was obtained. In extending The Paseo to the south, a variety of different widths and designs were used.

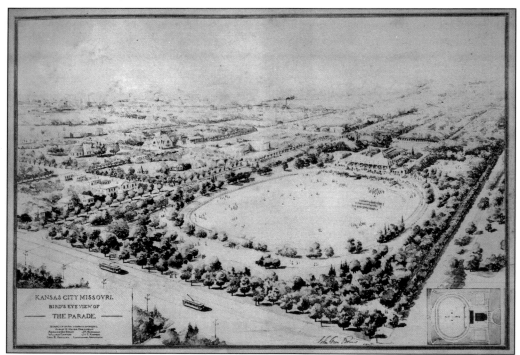

In 1900, almost 21 acres had been acquired for The Parade. The former circus ground was nearly level, and the south half was well wooded. This bird's-eye view of The Parade is looking southeast with cable cars on Seventeenth Street. With slight modifications, the park was completed by 1904 as planned. It became one of the most used playgrounds in the city. (Courtesy of BPRC.)

In 1902, The Parade grounds were graded and shaped. Medium-sized trees from the boulevards, six to eight inches in diameter, were planted, and in one season, transformed it into a well-shaded park. (Courtesy of BPRC.)

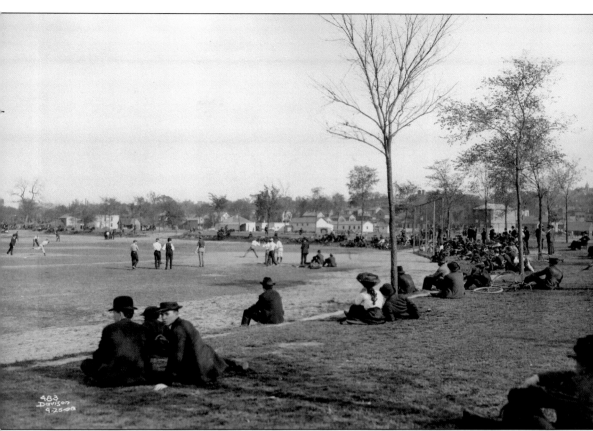

The sunken field of five acres, where the ball fields were located, was completed in 1904. The wide-open field was suitable for all types of team games and military parades. When the field was flooded in the cold winter months, it made an excellent skating rink. In this early photograph, a lively game of baseball is underway. The pitcher has just delivered his throw, and the batter looks ready to swing. The raised track around the field provided seating for the spectators. The homes in this area were modest in nature, and the residents used the park as a place to play and forget their cares for a few hours. Many of the park improvements made in the first decade were to improve the quality of life of these families. (Courtesy of BPRC.)

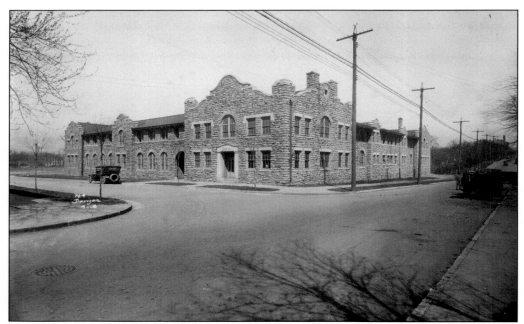

Between 1907 and 1912, a general operating plant, incorporating a machine and repair shop for the entire park and boulevard system, was built at Seventeenth Street and Woodland Avenue. All necessary repairs and maintenance of sprinklers, wagons, and other tools, including horseshoeing, were done at the new shop. In 1907, the repair shop started manufacturing concrete drinking fountains, horse-watering fountains, and playground apparatus. In 1914, an old manure dump in the southeast corner was filled, thus eliminating a long-standing nuisance. In 1916, a stable and storage yard was added. The photograph below is of a park-built drinking fountain. (Both, courtesy of BPRC.)

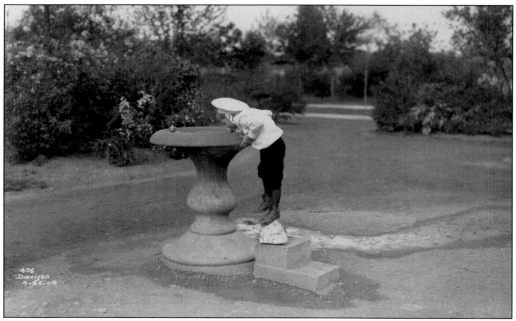

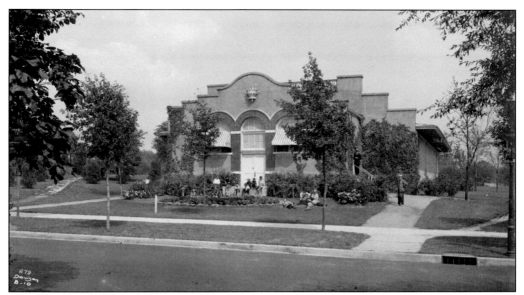

The first public bath was built in 1904 on the south side of The Parade. Epperson Megaphone Minstrels, seen below in 1906, raised the money for the building. The Epperson Megaphone Minstrels were a popular group of talented local businessmen. Howe, Hoit & Cutler designed the building with shower, baths, and a swimming pool. From June to October 1907, 47,676 bathers used the facilities. Ninety percent were males. Bathers were allowed to bring their own suits and towels, but they could be rented at 5¢ each. However, no bather who could not afford the small charge was refused, and suits and towels were provided for free. The public bathhouse was converted in 1919 for the exclusive use of the black community. (Above, courtesy of BPRC; below, courtesy of MVSC-KCPL.)

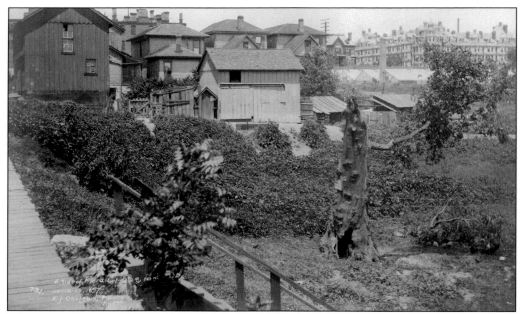

The chain of parks on The Paseo started at Ninth Street. This June 1897 photograph is looking northeast between Ninth and Tenth Streets. The lands for the parkway were acquired in 1896 and 1897. The housing along the roadway was removed by April 1898. (Courtesy of BPRC.)

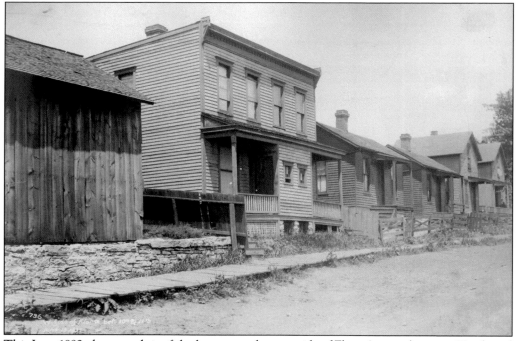

This June 1892 photograph is of the houses on the west side of Flora Avenue between Tenth and Eleventh Streets. They were demolished to make room for The Pergola in the median of The Paseo. Little thought was given to where the tenants of these structures were to go after their homes were destroyed. (Courtesy of BPRC.)

The 1899 fountain at Ninth Street was a joint design of Kessler and John Van Brunt. The cut-stone, oval fountain pool was approximately 60 feet at its widest point and contained a single two-inch water pipe in the center. The south half of the basin featured a cut-stone balustrade. In 1909, a monument to August Meyer was installed at Tenth Street. This photograph was taken around 1907. (Courtesy of BPRC.)

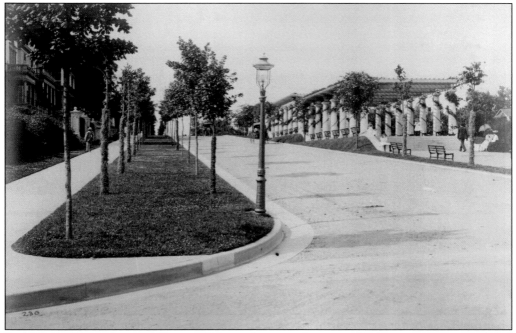

By 1898, the houses between Flora and Grove Avenues, shown on the facing page, were replaced with The Pergola. This 1903 photograph looks north from Eleventh Street at The Pergola and southbound roadway of The Paseo. (Courtesy of BPRC.)

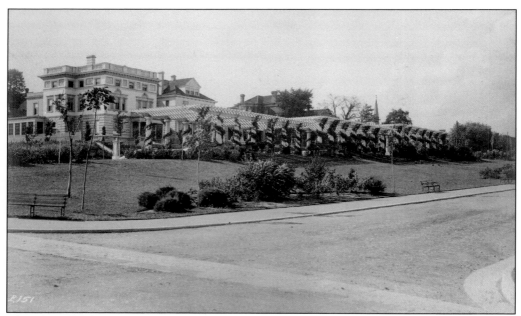

The entire Tenth Street block of The Paseo slopes from north to south as well as west to east. The mostly limestone pergola has three separate levels. This 1900 view is at Eleventh Street and the northbound lane of The Paseo. In addition to showing the recently completed Pergola, it shows newly constructed mansions on the west side of The Paseo. (Courtesy of BPRC.)

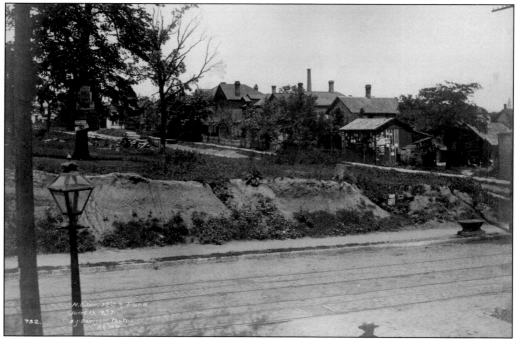

The land between Grove and Flora Avenues and Eleventh and Twelfth Streets was in an undeveloped, rough condition. This 1897 photograph shows that block before The Terrace was built. (Courtesy of BPRC.)

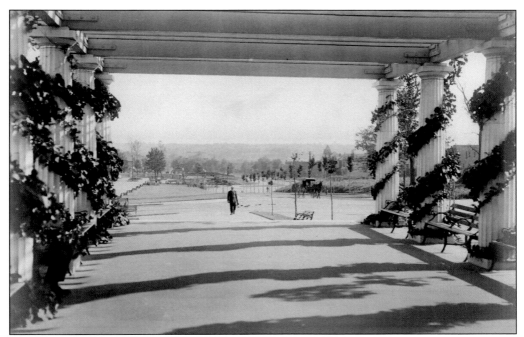

Regularly spaced, fluted columns support the open-latticed roof of The Pergola. This 1903 view from the south end of The Pergola shows the upper level of The Terrace and the sunken garden beyond it. (Courtesy of BPRC.)

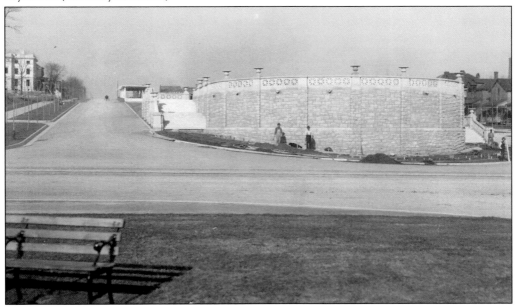

The slope from Eleventh to Twelfth Street is several feet. The median was purposely designed to not follow the slope. The south end of The Terrace, shown here, provided the perfect vantage point to view the elaborate sunken flower garden in the next block. The large, circular retaining wall is rough-cut limestone. The workers were taking a break in this 1900s photograph, looking north from Twelfth Street. (Courtesy of BPRC.)

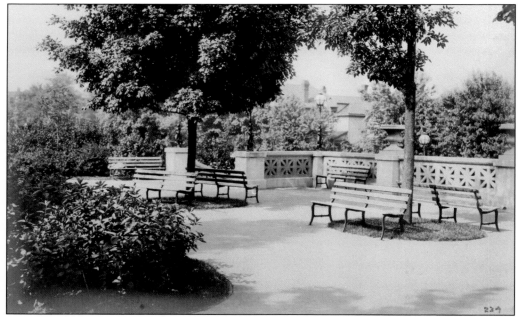

From Eleventh to Twelfth Streets, the top of The Terrace was a plaza with walkways, landscaping, and benches. Stone stairways at the southern end connected the plaza to the roadway and the sunken garden. This 1903 photograph shows the south end of The Terrace looking southeast toward Twelfth Street, which is about 20 feet below. (Courtesy of BPRC.)

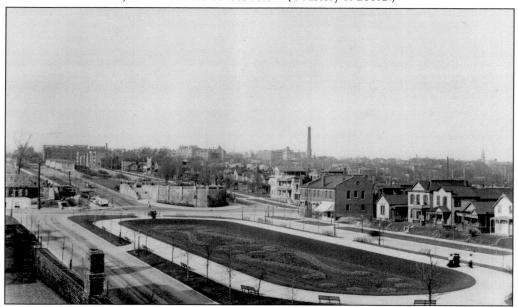

A sunken flower garden was constructed in the median between Twelfth and Thirteen Streets. This 1905 view looking northeast from Twelfth Street shows The Terrace and the east side neighborhood. A large, decorative drinking fountain was planned for the center of The Terrace's south wall; however, a fountain similar to John Van Brunt's original design was not added until 1922. (Courtesy of MVSC-KCPL.)

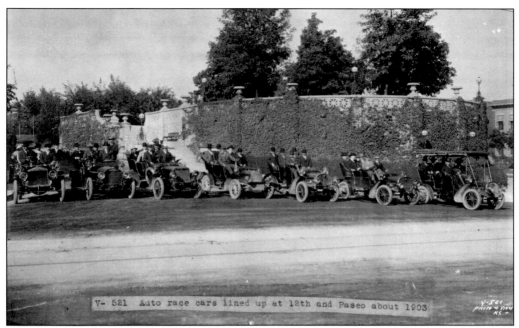

The title on this photograph is "Auto race cars lined up at 12th and Paseo about 1903." The cars, lined up in front of The Terrace on Twelfth Street, appear to be fully loaded with passengers. Perhaps they are there to view the race, rather than participate. (Courtesy of MVSC-KCPL.)

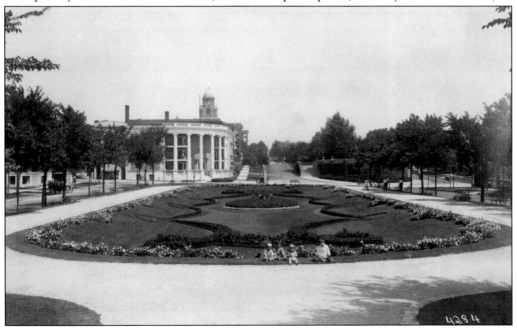

At the north end of the sunken garden stood a 6,500-pound bronze Spanish cannon that was five feet tall at its muzzle. The cannon was dedicated in 1899 as a monument to the recent Spanish-American War. The sunken flower garden would be redesigned several times. This 1908 view of the garden shows maturing trees and new apartments on The Paseo. (Courtesy of MVSC-KCPL.)

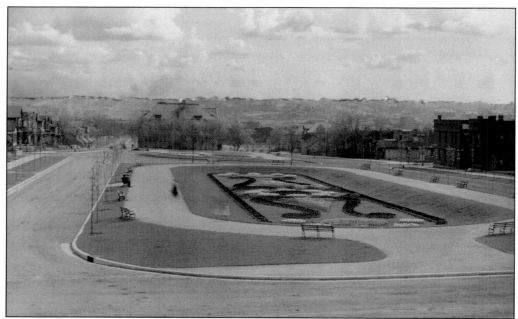

This 1906 view of the sunken garden from The Terrace shows the developing neighborhoods south of The Paseo and Chace grade school in the background at center. The Paseo median between Fourteenth and Fifteenth Streets could not be improved until the school was demolished in 1908. (Courtesy of BPRC.)

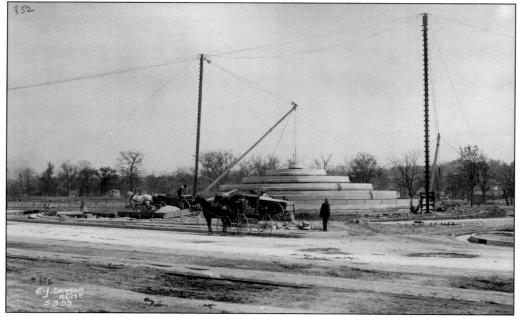

The first fountain constructed by the park department was south of Fifteenth Street and The Paseo. Kessler modeled the fountain after the *Fountain of Latona* in Versailles. Instead of a traditional basin set into the ground, this fountain rose above the ground in five circular terraces. The lower terrace was 86 feet in diameter. The highest was 15 feet above the ground. (Courtesy of BPRC.)

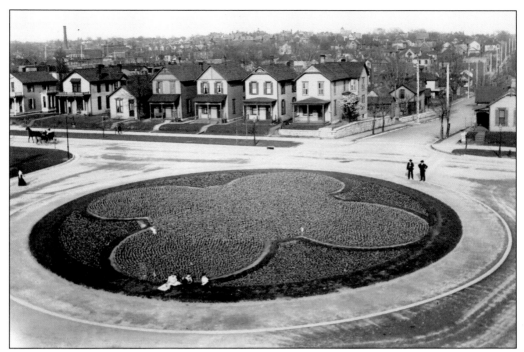

At Thirteenth Street and The Paseo, south of the sunken garden, a circle intersection was constructed with a slightly raised flower bed. This rooftop view looks west at Thirteenth Street (Courtesy of MVSC-KCPL.)

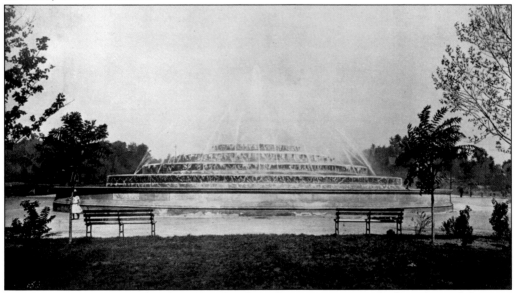

The large fountain, completed in 1899 for about $12,000, never worked as planned. It was a "waste" fountain, meaning the water was not recirculated but drained into The Paseo Lake. The fountain was a disappointment to Kessler and was labeled a white elephant. It was redesigned in 1908 but still did not recirculate the water. To minimize cost, the fountain only operated during afternoons and at night. (Courtesy of MHM.)

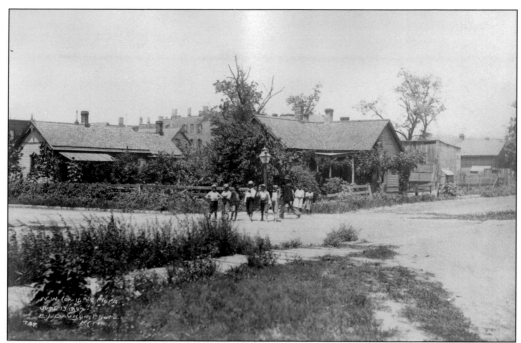

One of the first lakes constructed by the park department was The Paseo Lake, located in the median between Sixteenth and Seventeenth Streets. The lake was specifically created in 1898 to collect the water used by the Fifteenth Street fountain. The photograph above shows The Paseo and Sixteenth Street in June 1897. The view below is looking north from Seventeenth Street. (Both, courtesy of BPRC.)

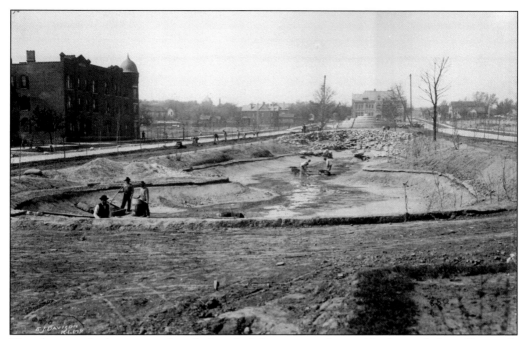

The photograph above was taken during the lake construction and looks south from Sixteenth Street. Great care was taken to use indigenous rocks, an irregular shoreline, and natural landscaping to make the manmade lake look as rustic and natural as possible. The lake occupied almost all of the 1600 block of The Paseo. (Both, courtesy of BPRC.)

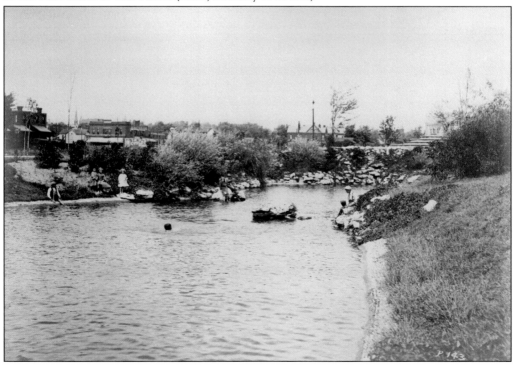

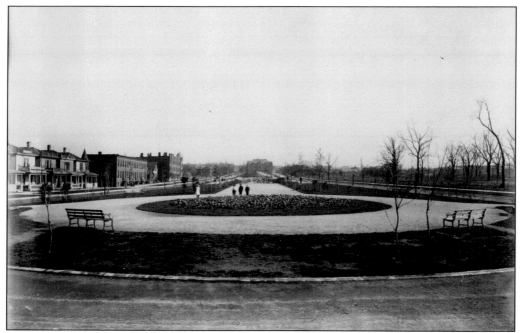

A flower garden plaza with walks, flower beds, and benches was developed for the level median between Seventeenth and Eighteenth Streets on The Paseo. The south end contained a large raised circular flower bed. Both photographs look north. The Fifteenth Street fountain and Chace grade school in the 1400 block, as well as the north rocky end of what would become the lake in the 1600 block, can be seen above shortly after the plaza was constructed. The view below shows the plaza in 1900. (Above, courtesy of MVSC-KCPL; below, courtesy of BPRC.)

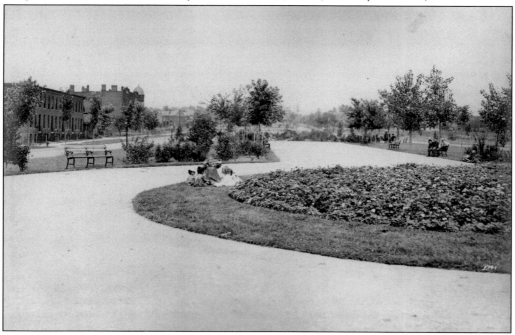

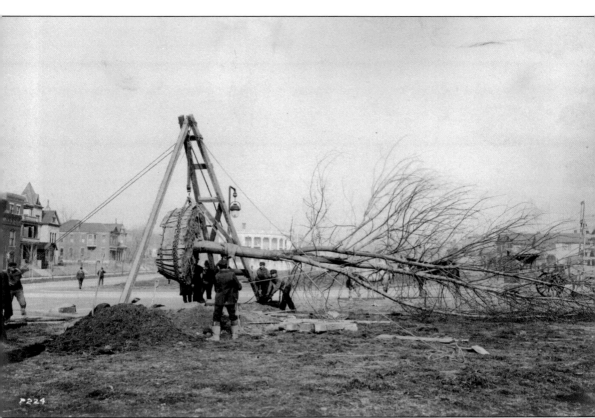

The tree plantings along the residential east and west sides of The Paseo followed the boulevard standard of three rows. A mixture of soft maples and elm trees were planted. When the maple trees reached a certain size, they were removed to allow the elms to reach their mature size. Thousands of extra trees were planted along the boulevards in this manner to provide an immediate visual impact and act as a nursery for future park needs. In 1914, a large number of maples, such as the 14-inch tree at Thirteenth Street and The Paseo, pictured here, were transplanted. In that same year, many "temporary" trees were moved from Gillham Road to The Parade, which had heavy tree losses due to the dry weather. (Courtesy of BPRC.)

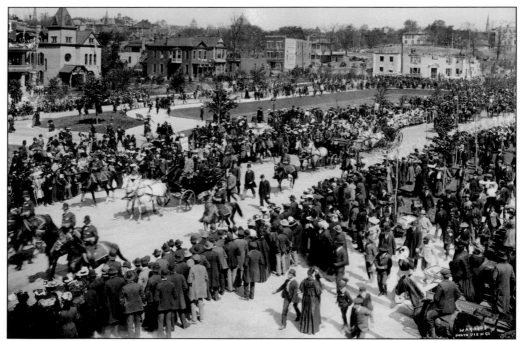

Pres. Theodore Roosevelt's train arrived from St. Louis early on May 1, 1903. He left the train depot escorted by carriages, mounted police, and the Missouri National Guard's 3rd Regiment. The route was along the new boulevard system. They passed along The Paseo, pictured above looking southeast, with the sunken garden at top. The picture below looks northeast; The Terrace is in the center upper third, and the New York Apartment building is under construction to the left. The sunken garden is in the middle. On The Paseo, over 20,000 people greeted the president. The retinue then moved on to Gladstone Boulevard, stopping at Scarritt's Point. They returned to the downtown Baltimore Hotel for lunch, and after a brief visit to Kansas City, Kansas, President Roosevelt left by train. (Both, courtesy of MVSC-KCPL.)

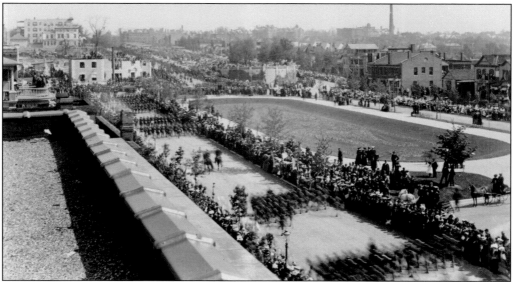

Five

THE LOCAL PARKS

The 1893 Report of the Board of Park and Boulevard Commissioners proposed four classes of parks. The smallest parks were considered local playgrounds or public squares. Five were recommended. Four ranged in size from 1.25 acres to 2.8 acres. The fifth was larger, at 9.7 acres. However, size alone did not dictate the function of a park. The local parks were intended for children's play and games, while also providing a place where the tired parents and their children "may spend a few hours, invigorated by refreshing breezes, and encouraged by pleasing surroundings."

Three of the new parks were in densely populated locations. North Square was proposed for the crowded neighborhoods near the Missouri River. High School Square between Eleventh and Twelfth Streets was for the central section of the city. Holmes Square served the densely settled area to the south between Eighteenth and Nineteenth Streets. Independence Plaza was proposed to improve an ugly section of Independence Avenue in the developing and more exclusive Pendleton Heights neighborhood. Independence Plaza was located on both sides of Independence Avenue between Park and Brooklyn Avenues. Walnut Grove, the largest of the five playground parks, was covered with good trees and intended for the developing east side.

At first, only open spaces with small areas for playground equipment were provided. By 1911, however, gymnastic apparatus such as swings, slides, and merry-go-rounds were installed in all the parks, not just the smaller ones. In addition, trained attendants were hired for each park to direct children's play, teach them to play well together, and protect the children's rights to use the playground against older boys. Shelters with toilets and multipurpose meeting and classrooms were built at most local parks. And in some, where many of the houses surrounding the park did not have bathrooms, bath facilities were added.

In 1896, Holmes Square was the first park acquired by condemnation and the first improved. The park occupied the city block between Campbell and Holmes Streets and Eighteenth and Nineteenth Streets. The agent of the estate that owned the block appealed a suit to the Missouri Supreme Court testing the city's method of condemnation. Properties closest to the improvements were assessed more than properties farther away. In a unanimous opinion, the court upheld the condemnation method. The cost of acquisition was $84,458.48. The photograph above shows the land in 1895 prior to being acquired. The view below is of the southwest corner of the future park. The corner grocery store is facing Holmes Street. All the structures were removed during the park construction. (Both, courtesy of MVSC-KCPL.)

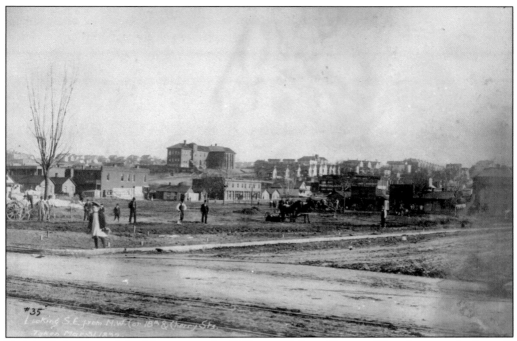

By March 1897, work had begun on the 2.79-acre Holmes Square. The photograph above is looking southeast from Eighteenth and Cherry Streets. This southern area of the city was densely populated by the newly arrived day laborers. By 1905, Holmes Square contained a shelter house, sandboxes, and open lawns for play and sports. The picture below is dated August 1907 and shows the open play areas before the outdoor gymnasium was installed. The boys in the center appear to be playing marbles. (Both, courtesy of BPRC.)

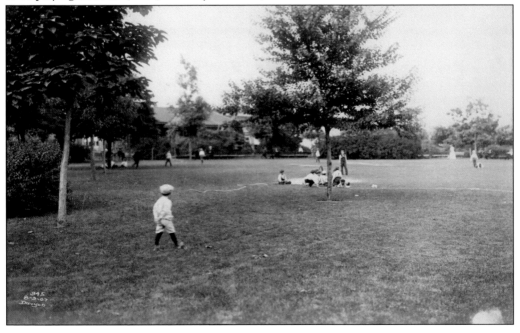

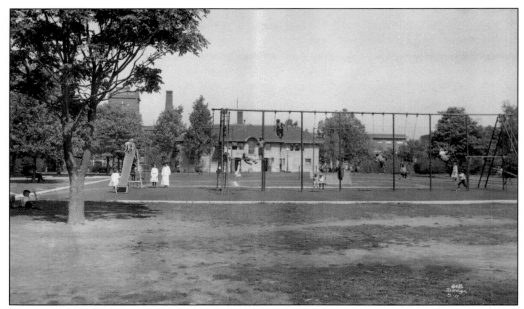

In June 1907, swings, teeter-totters, two merry-go-rounds, improved sandboxes, and gymnasium equipment were installed at Holmes Square. They were popular additions to the park. The equipment was removed for winter storage. In 1909, a female director was hired to oversee the play. Attendance at the playground reached about 500 children daily. Both September 1907 photographs show the newly installed gymnasium equipment. (Both, courtesy of BPRC.)

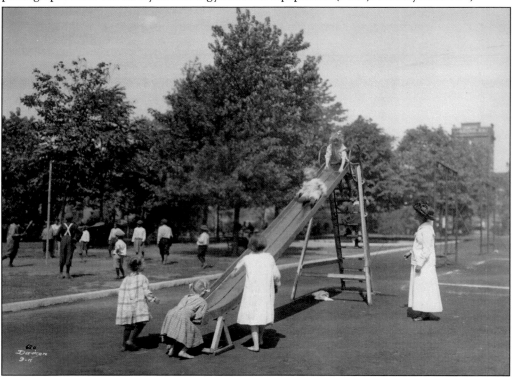

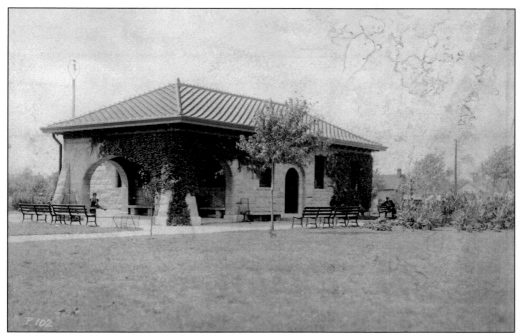

This September 1900 photograph shows the original Romanesque stone shelter house. While it contained restrooms for women, it did not have any for men. Facilities were provided for the men and boys when the shelter was expanded in 1909. (Courtesy of BPRC.)

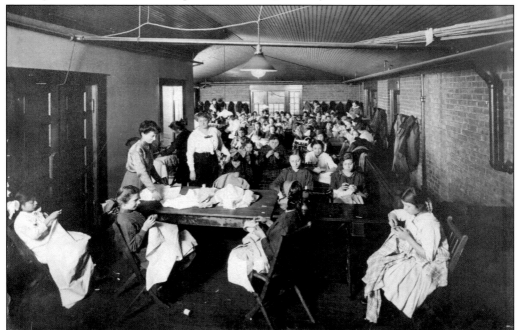

The shelter house contained a playroom and two club rooms, along with the women's restrooms. Organized activities included sewing, folk dancing, and basketry. This photograph inside the shelter house shows the popular sewing class offered by the Jewish Institution. (Courtesy of BPRC.)

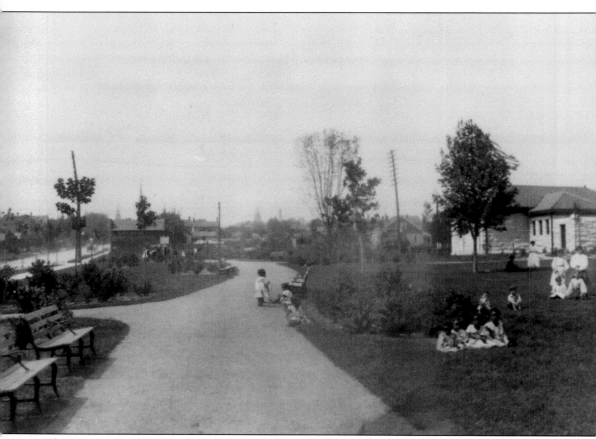

This panorama of Holmes Square dates to the early 1900s. The shelter house is visible at center. To the far right is what appears to be some sort of carnival ride or Ferris wheel. In 1907, there were complaints that in parks such as Holmes Square, the men in charge were unnecessarily severe

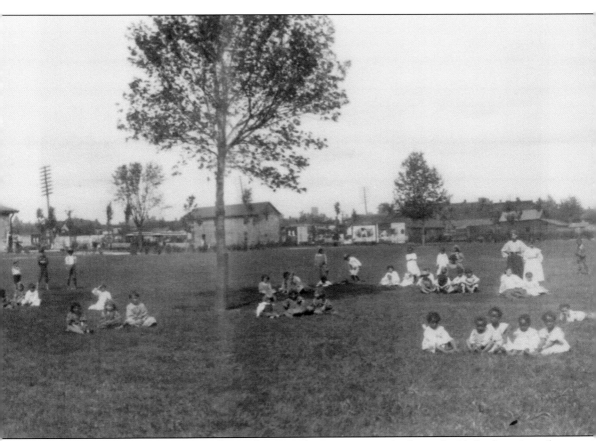

with children. The installation of new playground equipment resulted in a decided relaxation of park rules. W.H. Dunn, superintendent of parks, publicly stated, "We have no 'Keep off the Grass' signs. We are glad to see the children in the parks." (Courtesy of BPRC.)

In November 1909, a bath was added to the Holmes Square shelter. It contained eight individual showers and a 10-shower room for men; and five individual showers, an eight-shower room, and a tub for women. Towels and soap were 2¢ each. The addition also contained a gymnasium and restroom for men. From the opening until April 1910, the facility was used by 3,394 bathers. (Courtesy of BPRC.)

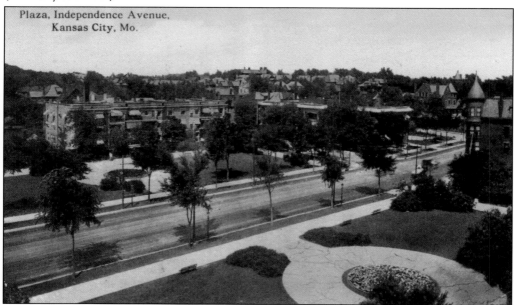

Independence Plaza is located on both sides of Independence Boulevard between Brooklyn and Park Avenues. The 1.73 acres were acquired for $133,922 in 1898. Per acre, it was the parks department's most costly park purchase. Deep gullies and cheap one-story buildings pocketed the ugliest spot on the original Independence Avenue. On either side of the gully were large mansions. (Courtesy of HKCF.)

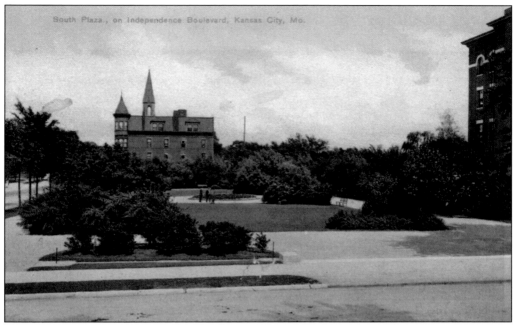

When a saloon was proposed for the site, the neighboring wealthy property owners encouraged the parks department to purchase the future Independence Plaza. By 1901, the gullies had been filled, a cut-stone retaining wall built, and iron fence installed. By 1906, improvements were completed with the installation of shrubbery, flower beds, walks, and benches. These photographs illustrate how something beautiful was designed to replace an eyesore. A neighborhood nuisance was converted into a community asset. The redbrick building in the background of the photograph above is the Bonaventure Hotel, built in 1886. The taller spire in the distance is the Independence Avenue Methodist Episcopal Church. (Above, courtesy of HKCF; below, courtesy of MHM.)

Acquired in 1898 for $155,277.53, The Grove is located on 10.49 acres between Benton Boulevard and Fifteenth Street west of Chestnut Avenue. The Grove (originally Walnut Grove) saw few improvements because its combination of wooded and open fields supported most recreational activities. Kessler's original plans were simple, with the only improvements being walks through the shady groves, a few plantings of flowering shrubs, and entrance constructions. Over 6,000 cubic yards of dirt were used to level the open fields. By 1907, playground equipment was installed, and the park was a favorite for croquet. Later, because of the increasing population growth of the surrounding neighborhood, plans were made for a bathhouse, swimming pool, toilet, pergola, wading pool, and tennis courts. They were installed in 1911. (Above, courtesy of MHM; below, courtesy of BPRC.)

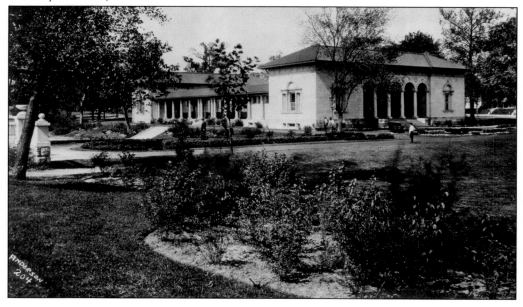

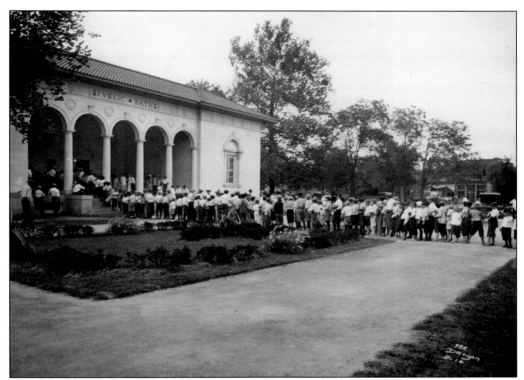

Kansas City firm Wilder & Wright designed the public bath in 1912. Known as the Roman Bath, it was a rectangle of Italian Renaissance design, with open colonnades connecting two pavilions on the east and west sides of the building. The structure, approximately $100,000, was located near the center of the park. The 12-hour bath service was wildly popular, as shown by the line of waiting bathers above. The bath contained multiple individual showers and shower rooms for men and women. Bathing suits for rent were 10¢. The restrooms were open 24 hours a day all year. The building also contained an administration office and two waiting rooms. The open-air swimming pool in the center measured 35 by 90 feet. (Above, courtesy of BPRC; right, courtesy of MVSC-KCPL.)

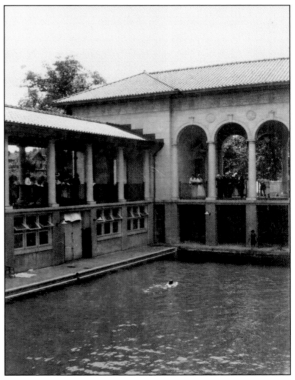

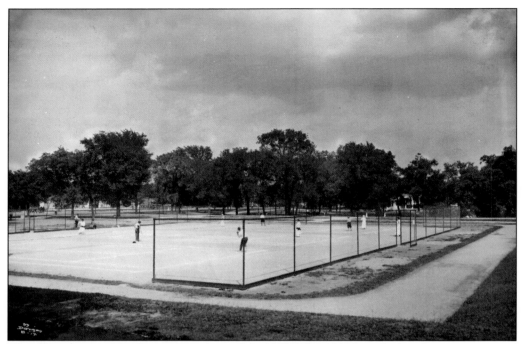

The Grove was put under supervision in July 1913. The 1914 board of park commissioners' souvenir booklet reported that 30,000 children had participated in regular playground activities such as basketry, folk dancing, sewing, weaving, storytelling, and games at The Grove. Croquet courts, horseshoe pits, and tennis courts were also available and heavily used. (Both, courtesy of BPRC.)

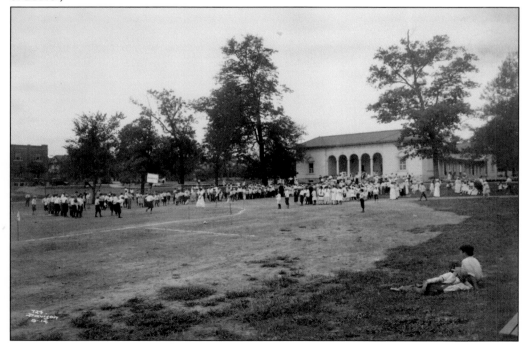

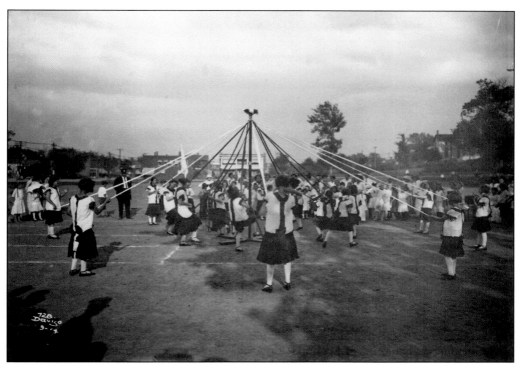

Kessler's 1911 plan for The Grove envisioned three recreational areas. In the middle of the park was the original grove. West of the grove was the area set aside for women and children. The east side was for the men and boys. The baseball field was on the eastern side. The outdoor swimming pool, while open to both sexes, was primarily used by men and boys. (Above, courtesy of BPRC; below, courtesy of MVSC-KCPL.)

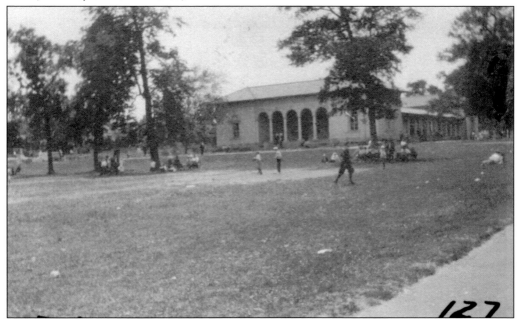

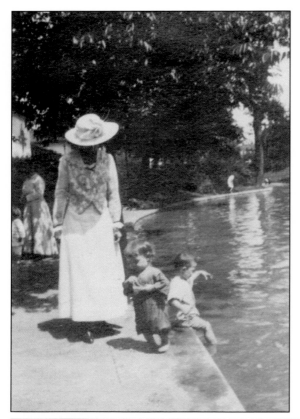

In 1911, work began on The Grove wading pool for women and children. It was constructed in the old creek bed on the south edge of the central wooded area of the park. It was of naturalistic construction, with curved edges, overhanging trees, and nearby shrubbery. The cost was $6,700. The wading pool became immensely popular. The 1914 board of park commissioners' souvenir booklet reported that about 500 children used the wading pool daily. (Left, courtesy of MVSC-KCPL; below, courtesy of BPRC.)

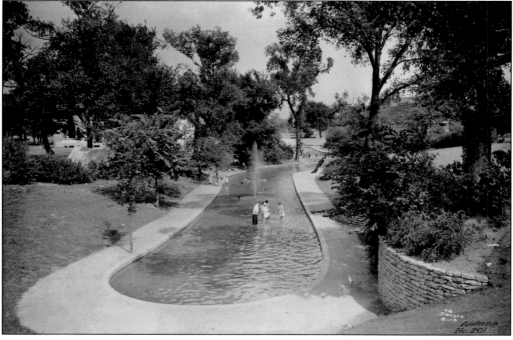

Six

SWOPE PARK

In 1896, Thomas H. Swope approached Robert Gillham, park board commissioner, about donating land for a park. Delighted, Gillham took Mayor Jones to see the property, and two weeks later, the mayor and park board announced Swope's gift of over two square miles of land, to be named Swope Park. It would be the second-largest park in the country. Pres. August Meyer believed that a complete system of parks requires both small interior parks, large outside parks, and rural parks. Swope had purchased the 2,000-acre "Mastin's Park" property in 1893 with the intention of giving part of it to the city when he died, but he realized the advantage of having a park while he was still alive and gave the gift outright. The newspaper estimated the value at $130,000.

Meyer and Kessler were thrilled and began making plans to incorporate the new land into the park system. The land was outside the city limits. There were acres and acres of meadows, forests covered over half the area, and picturesque Blue River Valley ran through the park with highlands on each side. But there was nothing at the location; there was no streetcar or urban trolley for the population to use to get to the park and nothing to do once they arrived. The park board had work ahead.

Swope's gift was received with wild enthusiasm. On June 25, 1896, a city holiday, the celebrations began with a parade led by the local bicycle clubs and the 3rd Regiment band. Following the parade, approximately 18,000 people made their way to Swope Park on foot, carts, horses and buggies, and by excursion trains.

Swope, a shy bachelor, avoided the limelight. During the dedication he chose not to be on the stage, nor did he ride with the mayor at the head of the parade. In fact, his only known comment was a note given to a *Star* reporter, which read, "I have often heard it said that gratitude is a scarce article in the world, but from this time on I shall reject & ignore that pessimistic sentiment."

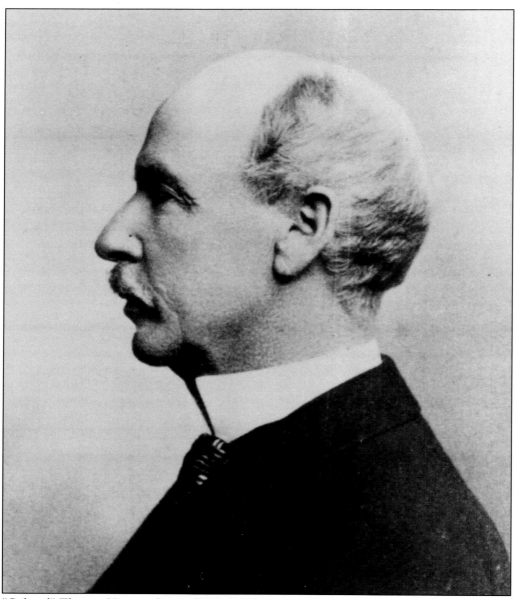

"Colonel" Thomas Hunton Swope (1827–1909) came to Kansas City in 1857 after purchasing some property in Kansas City and the surrounding area. He kept it and bought more. By the time of his death, he was the largest individual landowner in Kansas City. His estate was estimated to be worth more than $3 million. Besides the land for Swope Park, he donated 3.5 acres at Twenty-second Street and Tracy Avenue to the Women's Christian Association. A building for the Gillis Orphan's home and the Margaret Klock Armour Memorial home for aged couples were constructed on the land. Swope also donated the land east of Gillham Road between Twenty-third and Twenty-fourth Streets for the new city hospital (1908). Swope moved from his attractive country estate opposite the entrance to Swope Park to his late brother's mansion in Independence, Missouri, in 1900. The frugal Swope rode the electric car every day to work in downtown Kansas City. His title was honorary, not from military service. (Courtesy of BPRC.)

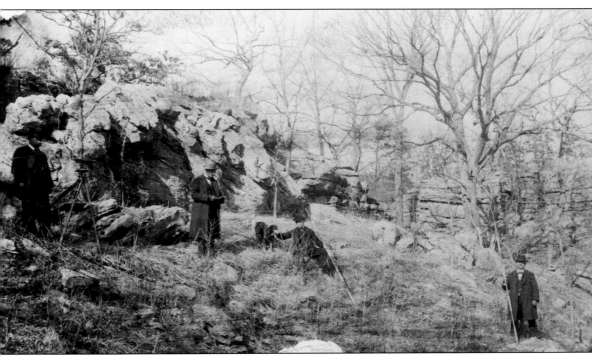

When he donated the park, Swope neglected to mention that he had given former mayor J.W.L. Slavens an 18-month lease on the land. Slavens used the property for cattle and did not want them disturbed. He agreed to allow a Swope Park dedication and a survey of the property after he received a payment of $500. Work began on surveying the park in 1897. The donation was 1,333.99 acres. Pictured here are, from left to right, George Kessler, A. Van Brunt, an unidentified man with a dog, and Wilbur Dunn. In 1898, Kessler completed his first comprehensive plan for Swope Park. The park board adopted a resolution to appropriate money for park improvements one year later. The board also allowed the Kansas City Interurban Railway Company to construct a line between Swope Park and the city. (Courtesy of BPRC.)

Swope Park was improved as fast as funds would permit. A monumental entrance to the park and a large shelter building in a commanding position just inside the main entrance with a proper setting of formal gardens were the first improvements of importance. Kessler and John Van Brunt were the architects of the grand entrance. Designed as early as 1901, construction did not start until 1904. The simply designed but massive stone entrance was not completed until 1905. The

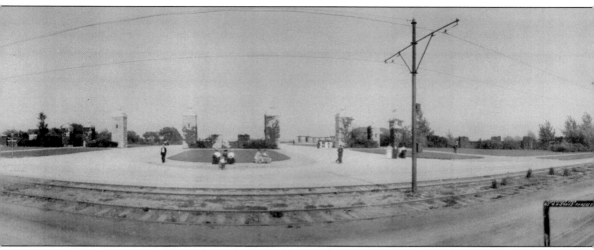

entrance spans two 40-foot-wide roadways and two 12-foot-wide walkways, with 22-foot-high piers capped with stone spheres flanking the roadways. Fifteen-foot piers of similar design are on either side of the walkways. Stone walls connect all the piers. The extension of the 150-foot-wide street railway line outside the city to the park cost the city nothing. The fare was 5¢. The street railway line was 150 feet wide. (Courtesy of Library of Congress.)

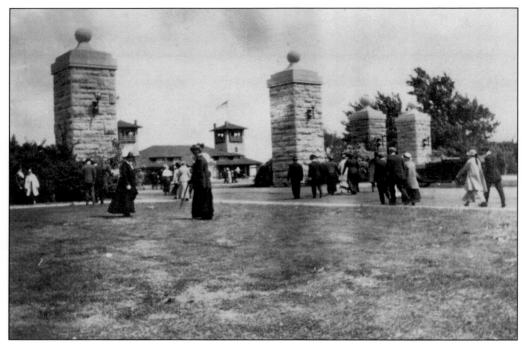

This 1915 photograph shows people going into the park. Visitors to the park in those days went by horse and buggy or used the Swope Park streetcar line. These visitors appear to have used the streetcar. In this view, Shelter No. 1, just inside the entrance, can be seen through the two roadway pillars. (Courtesy of MVSC-KCPL.)

Shelter No. 1, designed by Adriance Van Brunt & Brother architectural firm, was constructed in 1905 for $16,899. The structure was positioned on a knoll that was the highest elevation in the park with a commanding view east to the Blue River. The Mission-style building was constructed from fieldstone quarried in Swope Park. This view is of the west side that faces the entrance. (Courtesy of MVSC-KCPL.)

Shelter No. 1 has twin 50-foot observation towers on the north and south ends. A 16-foot veranda surrounding the building leads through rounded arched openings on the ground floor and both observation towers. Pergolas extended from each end of the building. To the east were sunken gardens, terraces, and walks. In 1906, it was reported that the sunken garden, terraces, and walks at the shelter building were completed and an excellent floral display maintained in the sunken garden throughout the season. A refreshment building, where visitors could obtain food and drink, was constructed northeast of the shelter. In 1918, an estimated 125,000 people attended a military air exhibit east of the sunken garden. (Above, courtesy of BPRC; below, courtesy of WAP.)

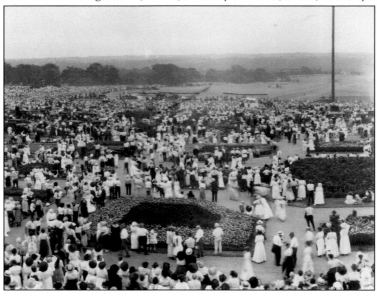

The Blue River meanders through Swope Park for 3.5 miles as it makes its way north to the Missouri River. Three branch ravines are locally named Wild Cat Hollow, Cannon Branch, and Prairie Branch. Along the river sides as well as the ravines are great rock formations known as Bethany Falls limestone. The suspension bridge is visible in this photograph of a fisherman and a hunter. (Courtesy of BPRC.)

The 1,334-acre park was divided into three sections. The west side included long stretches of meadows dotted with large forests. The east side of the Blue River Valley middle section was heavily forested hillsides. While many improvements had been made by 1916, much of the park was still unimproved. Nature, except for some dirt roads, was untouched and available for all to explore and experience. (Courtesy of MVSC-KCPL.)

The picturesque Blue River was a favorite for both boaters and fishermen. Even before the land was donated, small excursion-boat businesses had appeared downstream from Swope Park. Near the turn of the 20th century, as recreation and leisure for the working class was "invented," boating on streams became popular. This 1910 photograph shows men and women in a rowboat on Swope's Blue River. (Courtesy of MVSC-KCPL.)

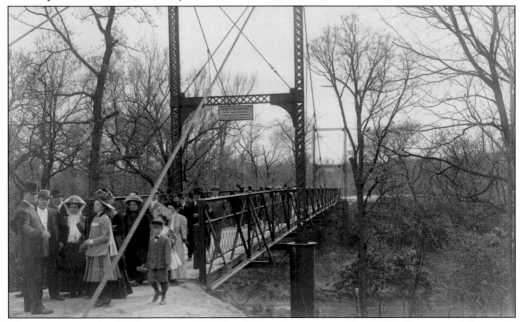

The suspension footbridge crosses the Blue River about one-and-a-half miles east of the main entrance. It cost $6,000 to complete in 1907. Suspended by two-inch cables from a steel superstructure, the bridge is 48 feet above the river and 277 feet long. The purpose of the bridge was to connect the proposed athletic field with the western part of the park. (Courtesy of MVSC-KCPL.)

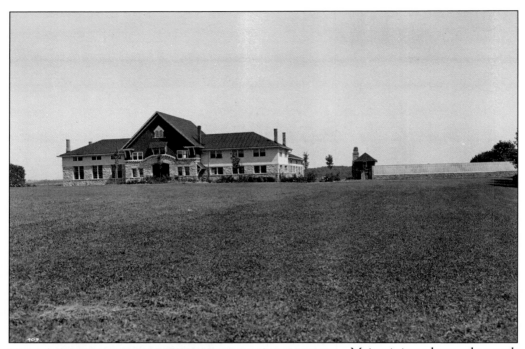

Maintaining a large urban park and boulevard system was a big undertaking. At first, 15 acres were set aside for a nursery for all the trees and shrubs of the park and boulevard system. The earliest greenhouse was built in 1905. Additional greenhouses were added in 1914, 1916, and 1932. By 1905, the supporting nursery in Swope Park covered 35 acres. Nursery stock at that time was 33,370 deciduous trees, 3,251 evergreens, and 61,971 shrubs. Bulbs and flowering annuals were also grown. Plans for the stables and storage barn were approved in 1905. Located behind the greenhouses was a rock quarry used for the park. The 1907 photograph above shows the stables and greenhouse. Inside the greenhouse (at left), workers appear to be preparing bulbs for the next season's plantings. (Both, courtesy of BPRC.)

George Kessler designed Lake of the Woods. It was constructed in 1908 by building a 35-foot-wide and nearly 100-foot-long dam on the western side of a natural basin. The basin, containing a small branch of the Blue River, occasionally flooded with backwater from the river. The resulting horseshoe-shaped lake had water surface area of approximately 10 acres. A large picnic area was on the northeast side. Lake of the Woods was a quarter of a mile south of the suspension bridge over the Blue River. (Above, courtesy of BPRC; below, courtesy of MVSC-KCPL.)

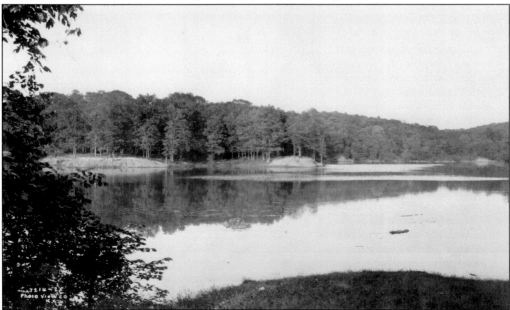

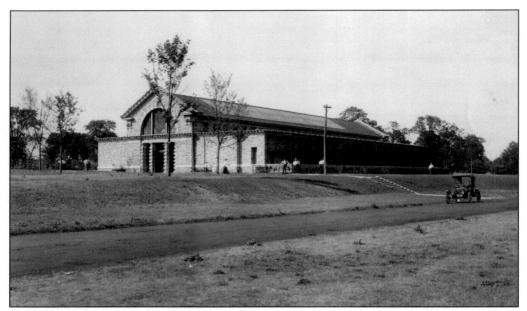

In 1908, a total of 60 acres of land were set aside to establish a zoological garden. The first building erected was the Bird and Carnivora House. The building, modeled after similar zoo buildings in New York and Chicago, was dedicated in December 1909. It is a limestone Romanesque structure 85 feet wide and 170 feet long. Carved stone birds and animal heads line the roofline. (Courtesy of MVSC-KCPL.)

The first grizzly bears, a mother and two cubs, arrived from the National Reservation in Yellowstone Park in August 1911. In 1914, there were four bears in the zoo and one escaped. He visited the golf course and spent time in Mount Washington Cemetery 11 miles away down the Blue River. In 1912, four bear pits, shown here, were tunneled into a ledge of solid rock. (Courtesy of BPRC.)

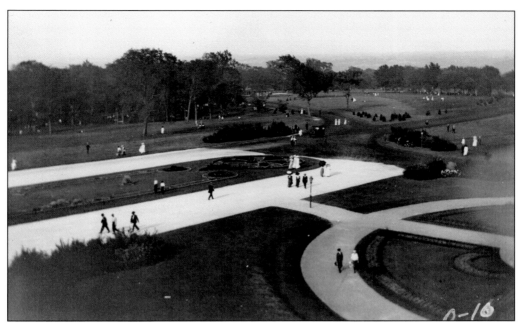

Weekends at Swope Park drew large crowds enjoying the weather, the gardens, and the natural beauty. Picnics, tennis, golf, polo, shooting, boating, and band concerts were some of the available activities. Numerous springs throughout the park were popular places to rest or picnic. Below, visitors are on their way to the new zoo building. After the zoo opened, conflicts occurred between visitors walking to the zoo through the golf course and the golfers. The players yelled "Fore" in vain at the strolling zoo-goers on the path, and many a match was held up as the zoo visitors purposely took their time strolling across the mall. In 1911, to address the interests of both groups, a new course was laid out south of the path. (Both, courtesy of MVSC-KCPL.)

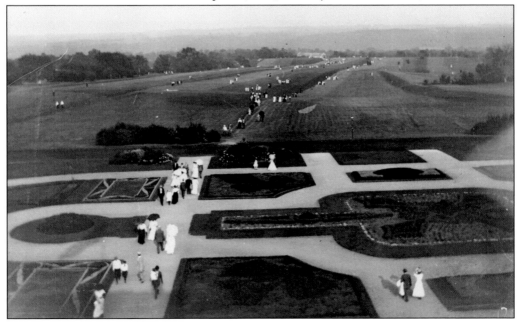

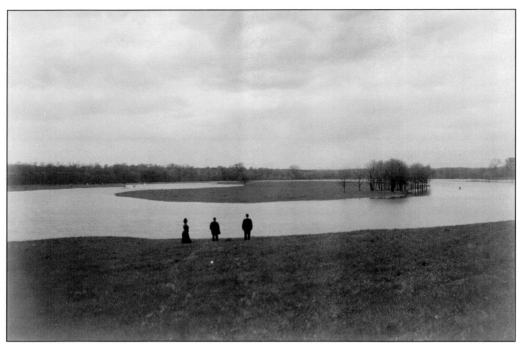

The Lagoon, north of the Lake of the Woods, was an elliptical water feature carved out of a 40-acre meadow east of the Blue River. In the center of the Lagoon was a large wooded island. Construction started on the Lagoon in 1908. The construction required the removal of about 40,000 yards of earth and the erection of a dam across the north end of the ravine in the northeast corner of the park. In 1909, a canal to fill the Lagoon from the Lake of the Woods was constructed. The Lagoon is six feet lower than the lake. It covered 25.5 acres and was exactly one mile around its outer shore. (Above, courtesy of MVSC-KCPL; below, courtesy of BPRC.)

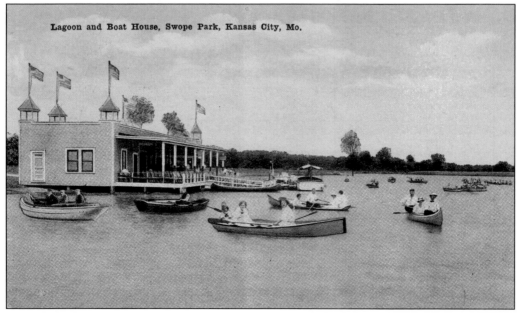

Lagoon and Boat House, Swope Park, Kansas City, Mo.

The Lagoon became one of the most popular recreation areas of Swope Park. A boathouse was added on the west side in 1912 for boat rentals and excursion boats. On June 1, 1922, a public bathing beach was added next to the boathouse. In 1922, a fountain spray designed by the engineering firm of Harrington, Howard & Ash was added. A central jet forced a stream of water 30 feet into the air, and around the central jet, 12 side jets sprayed water 20 feet in all directions. The photograph above was taken in the 1910s. The photograph below was taken in 1925. (Both, courtesy of MVSC-KCPL.)

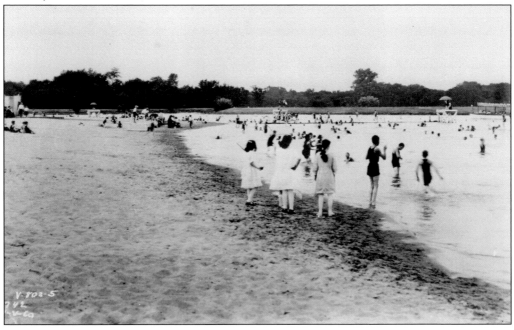

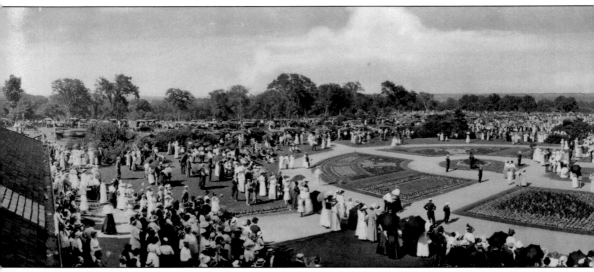

In 1912, Jacob L. Loose donated a flagpole, which was placed east of Shelter No. 1. The flagpole was 200 feet tall with a crow's nest 130 feet above the ground. A copper eagle weather vane with a six-foot wingspan was atop the pole. The stone base weighed 65,000 pounds and took 22 horses to pull it from the freight yards. From Green County, Missouri, it was the largest quarried stone from Missouri at that time. The dedication occurred on July 5, 1915. A crowd of 90,000 people

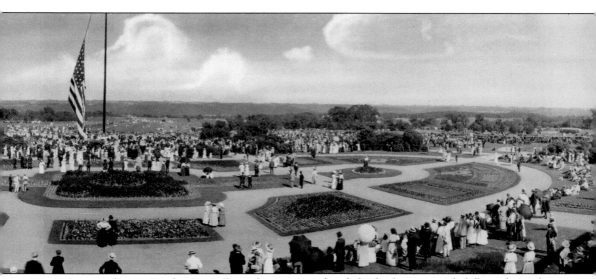

was in attendance. At the time, the pole was considered the highest unguided flagpole in the country. Shortly after the dedication, a windstorm blew off the top 15 feet along with the eagle. In 1931, a small aircraft crashed into the pole, killing a passenger. At that time, the pole's height was reduced to 175 feet. (Courtesy of BPRC.)

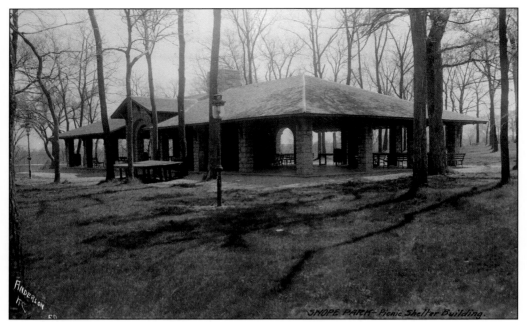

This photograph of Shelter No. 2 is from around 1915. The building was designed by Adriance Van Brunt and dedicated September 15, 1914. The building was of stone and yellow pine construction, with two large fireplaces and an exterior gaslight. Adding fireplaces for picnic cooking was a new feature in parks. (Courtesy of BPRC.)

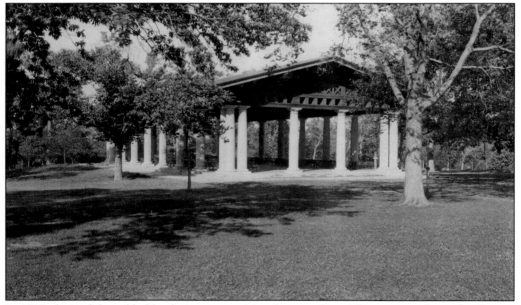

In 1916, the park board held a design competition for a pavilion. The winning design by George W. Huggins was an interpretation of a Doric temple. Underneath the Pavilion was a basement used for storing ice cut from the park lakes and used in the park buildings during the summer. At the April 1918 dedication, 1,000 people sat inside the Pavilion and another 9,000 were outside. (Courtesy of BPRC.)

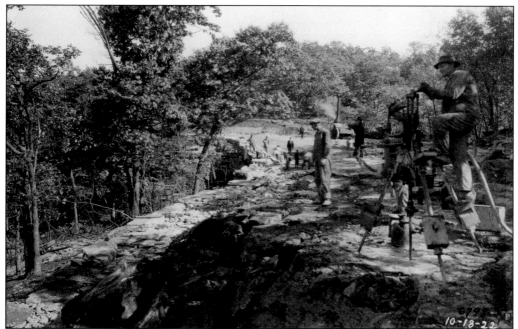

Golf was always an important feature of Swope Park. The first course, designed by a local professional golfer in 1906, was located in the meadow east of Shelter No. 1. Dubbed "the People's Country Club," it was a nine-hole course with no charge to play. The third and final golf course location was on the bluffs northeast of Lake of the Woods and east of the Lagoon. This course was carved from the virgin forest and was unsurpassed in its picturesque beauty. The 1922 photograph above shows the construction of the road to the course. The first clubhouse burned to the ground in 1922. The foundation and stones were salvaged to construct a new clubhouse, pictured below. Architects Shepard & Wiser designed it. (Both, courtesy of BPRC.)

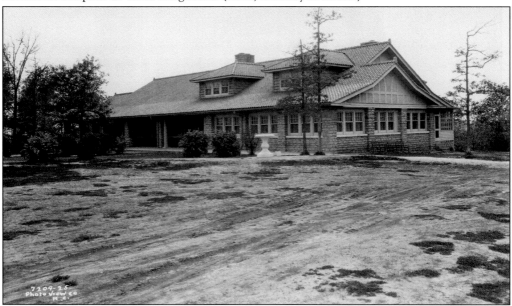

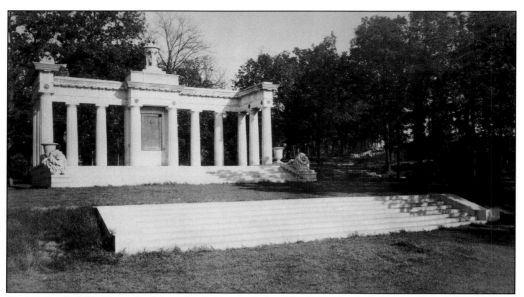

On a wooded bluff overlooking the Lagoon is the Thomas Swope Memorial. Kessler selected Kansas City architects Wight & Wight to oversee the project. The first stage of construction began in 1917 and was completed in 1918. Stairs built on two levels of terraces approach the memorial colonnade. Granite lions flank steps leading from the mausoleum. The mausoleum has Doric features that include a U-shaped colonnade that is 50 feet wide and contains 12 fluted columns. The 14-foot columns support a wide entablature with a decorative lantern atop. A Latin motto is inscribed above the central projecting bay, which contains a bronze plaque with a bas-relief profile of Colonel Swope and a dedication. The lady standing next to a lion in the photograph below shows the scale of the memorial. (Both, courtesy of MVSC-KCPL.)

The memorial is located north of the third and final location of the golf course and east of the Lagoon. The balustrade and fountain are down the hill 84 feet west of the mausoleum. The 72-foot-long balustrade is built at the very edge where the hillside steeply drops. The pedestal-type, six-foot-high fountain is in a semicircular pool about 25 feet in diameter. Built-in benches flank the fountain. Wight & Wight designed all elements of the memorial. They purposely used white stone to match the granite of the mausoleum, thus achieving a uniform appearance. Both fountain and balustrade were constructed in 1920–1923. The boathouse on the Lagoon could be seen from the memorial, as seen above, and the memorial (below) could be seen from the Swope Park grand entrance. (Above, courtesy of BPRC; below, courtesy of HKCF.)

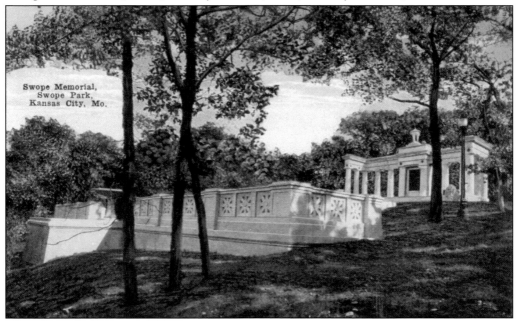

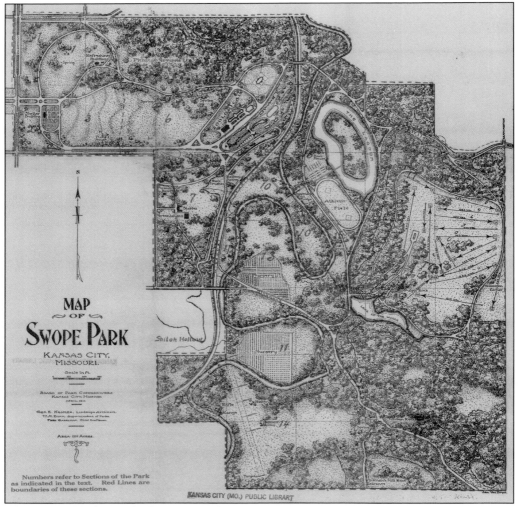

This 1911 map shows the location of the improvements to Swope Park. The grand entrance and Shelter No. 1 with sunken garden are located in the upper left. The meadow connects the garden to the zoo. North of the meadow in a wooded area are the picnic grounds. Southeast of the zoo is the Lagoon and athletic field. At center left are the foreman's house, the stables, and greenhouses. On either corner of Shiloh Hollow are the two nurseries. At lower left is the rifle range. The Lake of the Woods and golf courses are at center right. Large areas throughout the park were left in their natural wooded state. (Courtesy of BPRC.)

Seven

LIBERTY MEMORIAL

The area adjacent to the Union Station, opened on October 10, 1914, at Pershing Road and Main Street, was a cause for concern. The old depot in the West Bottoms had quickly become a lure for questionable business and patrons. Bars, flophouses, and bordellos were all within walking distance of the old depot. A hillside of shanties negatively impressed passengers stepping off the train. City fathers did not want the area around the new railway station to suffer the same fate. Many proposals were put forth concerning the area south of the new station and next to Penn Valley Park, but after World War I, the idea of a monument memorializing local war veterans found the necessary civic support and leadership. The newly formed Liberty Memorial Association, with R.A. Long as president, raised nearly $2.5 million in a weeklong fundraising campaign in 1919. In 1920, 33 acres, along with 8.5 acres donated by the Kansas City Terminal Railway Company in 1913, were added to Penn Valley Park for the memorial site. New York architect Harold Van Buren Magonigle won the design competition. The site was dedicated in 1921, and Liberty Memorial was dedicated in 1926. The memorial site was completed in 1926 when 2.67 acres were added on the west side for a connecting drive from Pershing Road to the Memorial Mall.

Kessler worked closely with Magonigle to design the memorial approaches and building site. Magonigle only designed and managed the construction of the memorial building and the south approach, the Memorial Mall. The four major elements of Magonigle's design were the Shaft, a great frieze on the north wall of the Memorial Court, and two small buildings to the east and west of the Shaft. Because of cost overruns and artistic disagreements with the association, Magonigle was not involved with the design or completion of the frieze or the north wall of the memorial. These were completed by 1935. Also in 1935, the last feature of Liberty Memorial, the Dedication Wall on Pershing Road, was completed.

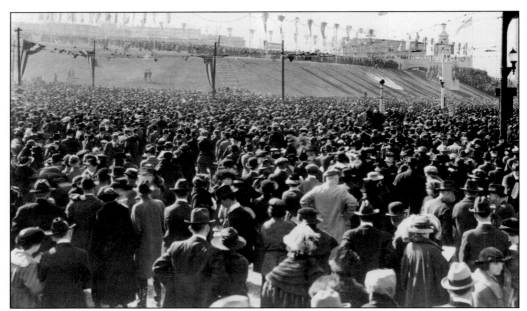

The Liberty Memorial site was dedicated on November 1, 1921, with an elaborate spectacle. The event was held during the third annual American Legion National Convention. A ceremonial stage with altar and speaker's pulpit was erected on the crest of the hill opposite Union Station. Sixteen state governors and more than 100,000 people attended. The five Allied military leaders joined Vice Pres. Calvin Coolidge on the stage. This was the only time the five leaders were ever together. From left to right, they are Lt. Gen. Baron Jacques of Belgium, Gen. Armando Diaz of Italy, Marshal Ferdinand Foch of France, Gen. John J. Pershing of the United States, and Adm. Lord Earl Beatty of Great Britain. As part of the ceremony, 10 white-robed, sandaled young women representing vestal virgins laid laurel wreaths at the foot of the altar. (Both, courtesy of MVSC-KCPL.)

The dedication of Liberty Memorial was on Armistice Day in November 1929. A speaker's pavilion was erected on the south side of the Shaft facing the long Memorial Mall. The pavilion was simply but beautifully draped in gray burlap to harmonize with the stone Shaft. President Coolidge delivered the keynote address before an estimated crowd of 150,000. (Courtesy of MVSC-KCPL.)

At night, the memorial Shaft and buildings were dramatically lit. The illusion of a flame was produced by the use of electrically colored steam. The upper part of the Shaft was lit by four banks of powerful floodlights placed two by two on each of the memorial buildings. This was so that the altar on top of the Shaft seemed to float in the night sky. (Courtesy of MVSC-KCPL.)

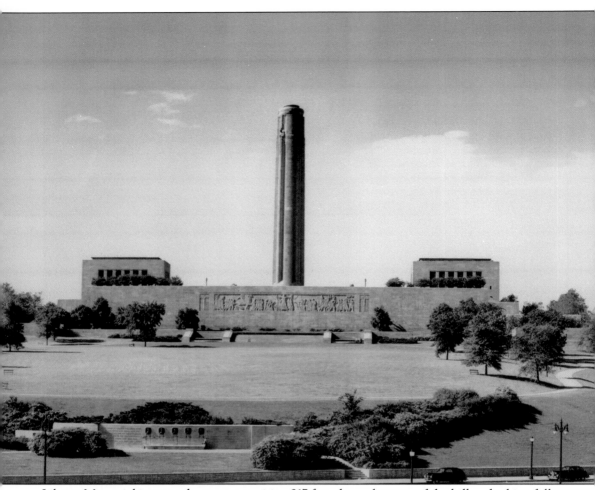

Liberty Memorial is a grand monument, rising 217 feet above the crest of the hill and taking full advantage of the site when viewed from Union Station. On the north side of the memorial, the change in elevation created an impressive wall where a great frieze could be carved. The top of the wall is slightly curved. The center of the wall's arc is one foot higher than the ends. All horizontal stonework joints are parallel to this curve. An optical illusion would have made the mass of the Shaft appear to sag in the center if the wall had not been slightly arched. Paths, steps, and terraces give visitors a series of changing views as they move upward from Pershing Road in easy stages to the higher terraces east and west of the buildings. When the memorial was dedicated, the great frieze, fountains, walks, and terraces were not completed. This 1935 photograph shows the memorial after completion. Works Progress Administration workers completed the landscaping. (Courtesy of MVSC-KCPL.)

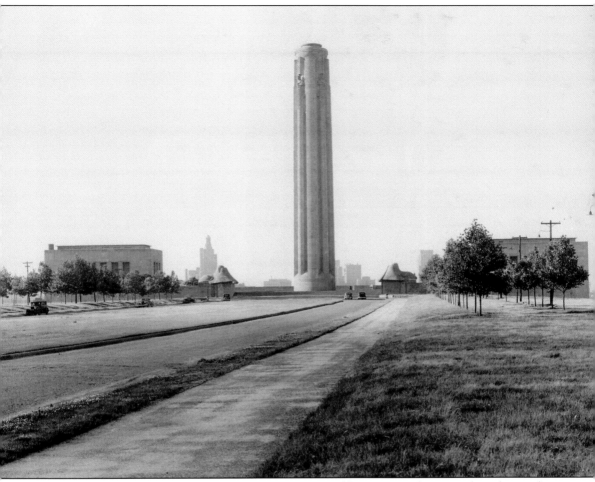

The Liberty Memorial site in Penn Valley Park is located between Pershing Road on the north, Kessler Road to the west, Memorial Drive on the south, and Main Street to the east. The main entrance to Penn Valley Park is on Main Street at Twenty-seventh Street. The south entrance to the memorial is a half block west of the Main Street park entrance. This southern approach to Liberty Memorial provides direct access to the Memorial Court, Shaft, and buildings. The Memorial Mall is a quarter-mile parkway featuring parallel roads flanked by lawns and walkways. A double row of trees line the sidewalk. The Memorial Mall topography is shaped into a catenary curve, with the lowest point about two-thirds of the way down the drive to the Memorial Court entrance. This gentle falling and rising slope improves the view from either end, adds interest, and relieves some of the formality of the overall design. (Courtesy of MVSC-KCPL.)

The southerly approach terminates at the Memorial Court, which was essentially a paved terrace. The Shaft was at the center of the terrace, with Memory Hall on the east and the Museum on the west. Two large sphinx-like figures, with wings concealing their faces, guard the entrance to Memorial Court. They were designed by Magonigle and are 32 feet long, 15 feet wide, and about 15 feet high above their pedestals. At the building entrances were huge cinerary-type urns decorated with a band of laurel and symbols of the services that contributed to the war effort. Memory Hall contains decorative maps showing the theaters of action of the US Army and Navy, all the training camps in the Untied States and Canada, and the convoy system. Massive stone steps with large buttresses connect the court to the north side of the memorial. (Left, courtesy of MVSC-KCPL; below, courtesy of LMA.)

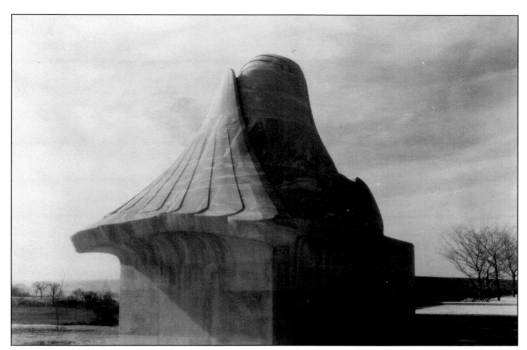

The Shaft is the major design element in the Memorial Court. It is a cylindrical limestone tower, 36 feet wide at the base and 217 feet tall from Memorial Court to an observation platform accessible by elevator and staircase. Above this platform is the Flame of Inspiration. Four buttresses and four round piers follow the Shaft with unbroken lines to the Altar of Sacrifice, which is surrounded by the 40-foot Guardian Spirits of the Flame: Honor, Courage, Patriotism, and Sacrifice. The bowl of the altar censer rests upon the tips of the guardians' up-stretched wings. These sculptures are by Robert Aitken. The sword each bears represents peaceful yet militant guardianship. A commemorative inscription and cornerstone are at the Shaft's base, and a bronze door into the Shaft has piece-work panels. The Memory sphinx-like figure faces east toward Flanders Fields, and the Future figure faces west. Future is veiled, and the folds of a heavy hood shroud the head of Memory. (Above, courtesy of LMA; right, courtesy of MVSC-KCPL.)

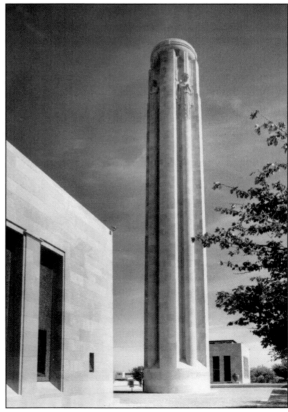

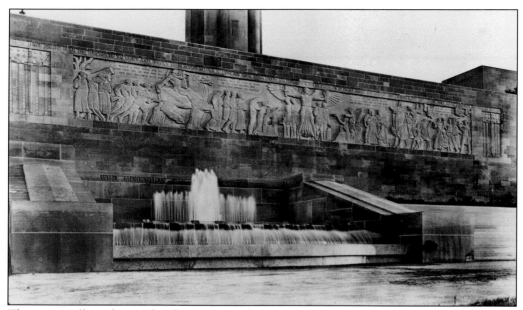

The great wall on the north side of Memorial Court is 488 feet long and 43 feet high. Edmond Amateis executed the great frieze sculpture, which is 145 feet by 19 feet. Wight & Wight working with the Olmsted brothers designed the north terraces, walls, steps, and fountains. Carved above each fountain is a passage honoring those who died in the war. The work was completed in 1935. (Courtesy of MVSC-KCPL.)

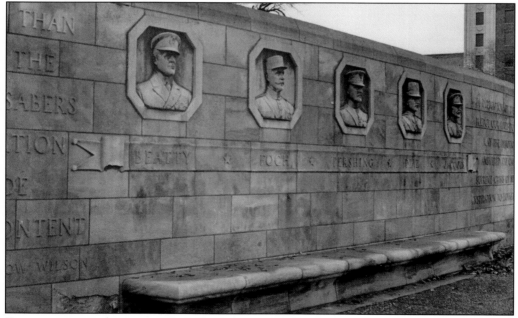

To commemorate the memorial's dedication, a curved limestone wall was built south of Pershing Road. Wight & Wight planned the wall in 1934, and it was completed in 1935. It contains the bronze portraits of the five Allied leaders who attended the dedication. In addition to the portraits are two quotes and stone benches. (Courtesy of MVSC-KCPL.)

EPILOGUE

Around 1920, Andrew Wright Crawford, a city planning expert from Philadelphia, said:

> Of all the actual accomplishments that American cities can boast, within the last twenty years, none surpasses the park and parkway system of Kansas City. That system, by and of itself, is making that city world famous. It is in its completeness, its pervasiveness, in the way it reaches every quarter and section of the city, that it surpasses the park system of other cities of the world.

The Kansas City parks and boulevard system history had a beginning but no ending. In 1893, the Board of Park Commissioners of Kansas City had a plan containing 9.85 miles of boulevards and 323.45 acres of parks. By 1920, the original plan was, in general and in detail, fully implemented, but additionally, it had grown and expanded with the growth of the city. The total area of parks and parkways acquired and planned had increased to 3,471 acres. Total mileage of boulevard and park drives improved and planned was 151 miles. The acquisition cost of land was $8.3 million. Total construction cost was $5.4 million.

By the late 1920s, the planned park and boulevard system was complete and would not materially change until after World War II. George Kessler designed virtually the entire system, and even after he moved his offices to St. Louis, he still consulted with the parks department during the later construction phases. This unique partnership between Kessler and the parks department gave the parks and boulevard system a unique uniformity throughout the whole city that did not exist anywhere else in the country. The parks were well distributed throughout the city and within easy walking distance for most residents. The boulevards and parkways provided connections to every part of the city in a beautiful and efficient manner.

It is impossible to share images of all Kansas City's historic parks and boulevards in this book. This epilogue contains a few examples of recreation facilities, parks, parkways, and decorative features added as the system expanded beyond the original 1893 Report.

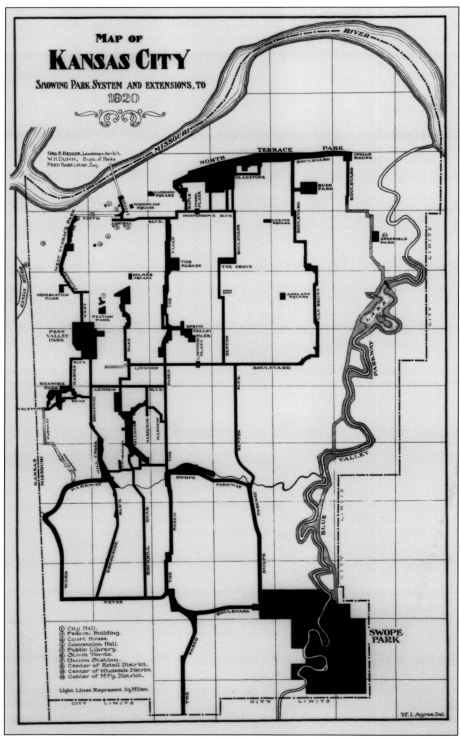

This map shows Kansas City's park system in 1920. (Courtesy of BPRC.)

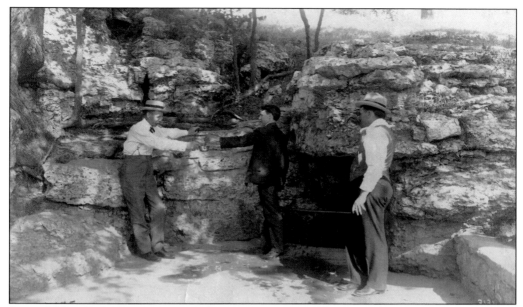

Spring Valley Park, lying in a natural canyon, was named because of its many natural springs. In 1901, the park board began the evaluation and acquisition for this parkland. A dam was built in 1905 at the lower end of the canyon to form a spring-fed lake. This picture, taken in 1905, shows a man who appears to be George Kessler enjoying the natural spring waters. (Courtesy of MVSC-KCPL.)

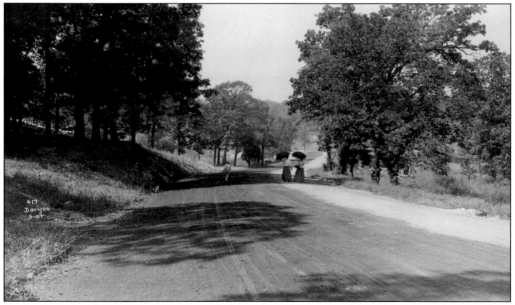

Real estate developers soon recognized the value adjacent parks and boulevards gave their properties. A large tract of wooded ravines and rugged cliffs unsuitable for buildings was donated for Roanoke Park. In 1907, Kessler recommended the property be kept as a "bit of wilderness, which is now its charm, and which would be entirely lost if attempts were made to finely finish any part of this valley." (Courtesy of BPRC.)

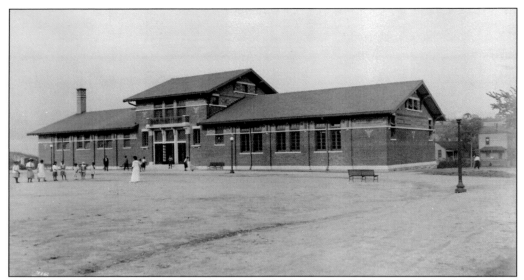

Garrison Square Park, on the northeast corner of Fifth Street and Troost Avenue, was completed in 1914, the date of this photograph. Architect Benjamin Labschez designed the field house. It featured a green tile roof and tapestry brick exterior. Showers for men and women were available along with a gymnasium, a library, and two club rooms. This park was for the surrounding black population. (Courtesy of BPRC.)

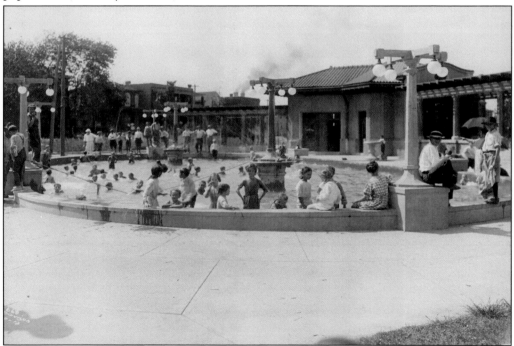

Washington Square Park (now named Columbus Square) was acquired in 1909. Outdoor gymnasium equipment was installed along with a wading pool and shelter house. This picture shows the wading pool in July 1913 on the southeast corner of Holmes Street and Missouri Avenue. A comfort station and pergolas were added in 1911. (Courtesy of BPRC.)

Gillham Road south of Armour Boulevard was a parkway of varying widths with two valleys. The parkway, passing through some of the best residential districts, connected Armour Boulevard to Swope Parkway. The design of the Harrison Parkway branch is one of the most beautiful in the system. Recreational facilities included several tennis court locations, bridle trails, athletic fields, and a combination wading and casting pool. (Courtesy of BPRC.)

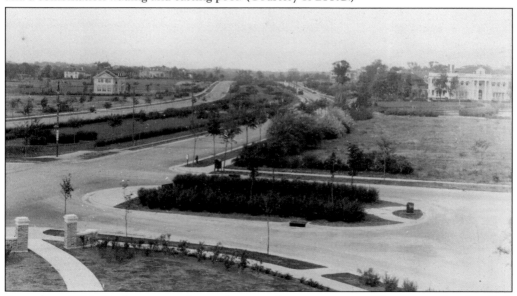

As early as 1906, Kessler proposed a southwest parkway to preserve "fine scenery" and to link the fast-growing southern residential districts. In 1908, the J.C. Nichols Company and the Ward Investment Company deeded several parcels of land to the city for what would become Ward Parkway. South of Fifth-fifth Street, the interior parking was formal. Decorative features include fountains, pools, statuary, and flower beds. This view is to the northwest from Fifty-ninth Terrace. (Courtesy of MHM.)

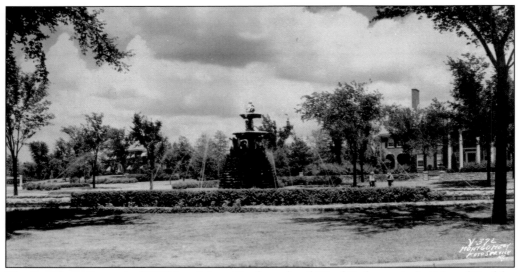

The Sea Horse Fountain (1925) is at Meyer Boulevard and Ward Parkway circle. Edward Buehler Delk designed the 100-foot-diameter circular pool with a sculpture in the center. J.C. Nichols donated the 17th-century Venetian sculpture. Total cost of the sculpture, pedestal, pool, and landscaping was $18,000. The fountain sculpture contains sea horses, cherubs, a child astride a dolphin, and lion head spigots. (Courtesy of MVSC-KCPL.)

The Scout, designed by Cyrus E. Dallin, was first exhibited at the 1915 Panama-Pacific Exposition in San Francisco. On its way back east, it was temporarily exhibited in Penn Valley Park. It proved so popular that money was raised to buy it. It was dedicated in 1922. (Courtesy of WAP.)

BIBLIOGRAPHY

Board of Park and Boulevard Commissioners, Kansas City, Missouri. "Report of the Board of Park and Boulevard Commissioners of Kansas City, MO. Embracing Recommendations for the Establishment of a Park and Boulevard System for Kansas City. Resolution of October 12, 1893." Kansas City, MO: Hudson-Kimberly Publishing Co., 1893.

Board of Park Commissioners. "Report(s) of the Board of Park Commissioners of Kansas City, MO., for the Fiscal Year[s] Ending 1905, 1906, 1907, 1909, 1910, and 1914." Kansas City, MO: Board of Park Commissioner.

———. "Souvenir—The Park and Boulevard System of Kansas City, Missouri." Kansas City, MO: Board of Park Commissioners, 1920.

———. "Swope Park Municipal Golf Courses." Kansas City, MO: Board of Park Commissioners pamphlet.

Board of Parks and Recreation Commissioners of Kansas City, Missouri. "Historic & Dedicatory Monuments of Kansas City." Kansas City, MO: Board of Parks and Recreation Commissioners, 1987.

———. "Swope Park History." Kansas City, MO: Board of Parks and Recreation Commissioners, 2004.

Chamber of Commerce of Kansas City, Missouri. *Where the Rocky Bluffs Meet.* Kansas City, MO: Smith-Grieves Company, 1938.

Haskell, Henry C. Jr. and Richard B. Fowler. *City of the Future, a Narrative History of Kansas City, 1850–1950.* Kansas City, MO: Frank Glenn Publishing Co. Inc., 1950.

Kansas City Star: December 21, 1893; December 27, 1893; June 7, 1896; April 29, 1901; July 17, 1904; July 27, 1907; August 8, 1911; May 12, 1912; August 11, 1914; and April 7, 1918.

Lee, Janice, David Bourtros, Charlotte R. White, and Deon Wolfenbarger. "A Legacy of Design: An Historical Survey of the Kansas City, Missouri, Parks and Boulevards System, 1893–1940." *Kansas City Center for Design Education and Research.* Columbia, MO: University of Missouri-Columbus, 1995.

Liberty Memorial Association. *The Liberty Memorial in Kansas City, Missouri.* Kansas City, MO: Spencer Press, 1929.

Piland, Sherry and Ellen J. Uguccioni. *Fountains of Kansas City.* Kansas City, MO: Lowell Press Inc., 1985.

Ray, Mildred. "Postcard Collection of Independence Plaza, Gladstone Boulevard at Scarritt Point, and Armour Boulevard." *Kansas City Times*: September 7, 1968; August 15, 1970; July 29, 1972; and March 7, 1980.

Whitney, Carrie Westlake. *Kansas City, Missouri: Its History and Its People 1808–1908. Vol. 3.* Chicago: J.S. Clarke, 1908.

Wilson, William H. *The City Beautiful Movement in Kansas City.* Kansas City, MO: The Lowell Press Inc., 1964.

DISCOVER THOUSANDS OF LOCAL HISTORY BOOKS
FEATURING MILLIONS OF VINTAGE IMAGES

Arcadia Publishing, the leading local history publisher in the United States, is committed to making history accessible and meaningful through publishing books that celebrate and preserve the heritage of America's people and places.

Find more books like this at
www.arcadiapublishing.com

Search for your hometown history, your old stomping grounds, and even your favorite sports team.